IMAGES
of America

FRENCH
SAN FRANCISCO

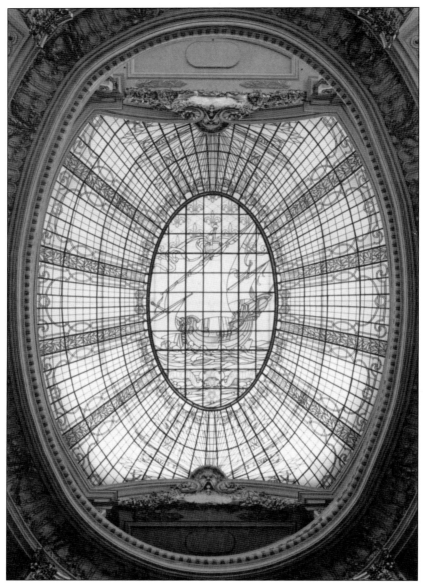

The City of Paris. This stained-glass window from the old City of Paris store's rotunda on Union Square can now be seen inside the Nieman Marcus store that replaced it in the 1990s. The large, beautiful glasswork depicts a sailing ship and bears the motto: "Fluctuat Nec Mergitur" (It floats but does not sink). This design represents the arms of the city of Paris. The Verdier family's first ship to San Francisco and their subsequent store were named for the French capital. (Robert E. David.)

On the Cover: The school Notre Dame des Victoires opened 18 years after the 1906 San Francisco earthquake and fire. It became the rallying point for the city's French families scattered by the disaster. The school's two buses picked up French children in their own neighborhoods until 1970 when the growing number of families driving their own cars made the service obsolete. (San Francisco Public Library.)

IMAGES
of America

FRENCH
SAN FRANCISCO

Claudine Chalmers, Ph.D.

ARCADIA
PUBLISHING

Published by Arcadia Publishing
Charleston SC, Chicago IL, Portsmouth NH, San Francisco CA

Printed in the United States of America

Library of Congress Catalog Card Number: 2007931271

For all general information contact Arcadia Publishing at:
Telephone 843-853-2070
Fax 843-853-0044
E-mail sales@arcadiapublishing.com
For customer service and orders:
Toll-Free 1-888-313-2665

Visit us on the Internet at www.arcadiapublishing.com

CONTENTS

ACKNOWLEDGMENTS

Gathering the scattered threads of San Francisco's grand old French community brought me to the doorsteps of many of their descendents, among them Bill Auradou, Nancy Newkom, Hal Fick, Alrene Flynn, Marc and Claudie Martini, Jean and Thomas Moulin, and Paul Roos Streiber. I have greatly enjoyed all of their accounts, memories, and photographs. I remain quite grateful for my past interviews with Henri Bordenave, Ernest Peninou, and Mireille Piazzoni. And my thanks go to Diane Alsterlind for her help with the Boudin family history. Robert E. David, a photographer on the staff of the Golden Gate Bridge Agency for 34 years, provided his expert help with photographing old documents and with precious information on the French Hospital and his own family.

I am grateful to members of today's French community who guided me to resources, and dug into their own archives: the dedicated Jean and Sara Gabriel, local historian Père Siffert, our "institutional memory" Henri Monjauze, and our dynamic vice-consul and amateur photographer Pierre Mattot.

This tale of San Francisco's Gallic pioneers was made richer by the contributions of collectors and historians both in California and in France. Bob Chandler dug into his own collection and the Wells Fargo Museum's collection, and then spent his own time reading my manuscript. Thanks also go to Susan McClatchy, Jan Ruff, Malcolm Barker, and Guy-Alban de Rougemont, as well as John and Joel Garzoli. In France, Jacques Perilhou provided not only treasures from his extensive library, but also patient advice and readings of the manuscript.

Four dedicated librarians offered guidance in tapping into their collections and resources:

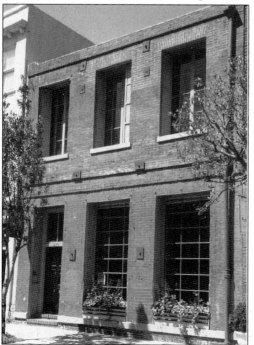

Christina Moretta at the San Francisco Public Library, Kathleen A. Correia at the State Library, Susan Snyder at Bancroft Library, and Lindsey Cleveland at the Nevada County Public Library. Arcadia Publishing's editor John Poultney was an excellent taskmaster and my Sierra Writers group a source of support and inspiration.

I thank all for their generous assistance in writing this celebration of the early French pioneers who helped make San Francisco the magnificent town it is today.

JACKSON STREET'S OLD FRENCH CONSULATE. Jackson Street's oldest building, located at no. 472, was home to San Francisco's French consuls in the 1860s and 1870s. The building's iron shutters, designed to protect occupants from possible fires, are typical of the 1850s when it was built. Nearby is French Captain Moulinie's building at 458 Jackson Street, which he rented to French wine merchants from 1854 to 1902. (Author's collection.)

INTRODUCTION

Many men from France roamed the American continent and the Pacific in the early 1800s. Louisiana had just been sold. Napoléon Bonaparte's bloody wars had lefts scores of French veterans adrift. French Canadian fur trappers continued to spearhead inland explorations westward. French missionaries, diplomats, and explorers were sent into the Pacific, especially after Tahiti and the Marquisas came under French rule. French villagers and townspeople, like those of Barcelonette in the French Alps, were settling in substantial numbers in South and Central America, seeking fortune away from home. Natural wanderers like the Basques, the Bretons, and the Bordelais took to the ocean as well. The seas and the continents were theirs for the taking.

A dream of conquest still lingered among California's early Frenchmen. In a secret 1844 memo attached to his extensive report on California, French attaché Duflot de Mofras concluded:

> Already mistress of the Marquesas and of Tahiti, one may picture the role France would be able to play by securing one of the Sandwich Islands, by buying the establishment at the port of La Bodega—which would be only the prelude to acquiring the whole of San Francisco, that key to the Pacific—by grouping around her Franco-Spanish catholic populations, by opening to our compatriots who are going daily to the United States, Buenos Aires, and Chili a great field of national colonization, and by restoring on a continent where our flag so long floated a new French America.

King Louis Philippe wisely passed, and the great plan remained a dream.

So it happened that Yerba Buena's earliest survey and—most importantly—earliest tavern were created by a Francophone, Jean-Jacques Vioget, who was a sea captain born in the Swiss Alps. Yerba Buena became the hub of an early "French connection" that grew between Vioget, San Jose's French pioneers Pierre Sainsevain and Antonio Suñol to the south, and John Sutter at his New Helvetia Fort to the north. In such a small community, a common language was a bond. "French" was used to describe all Francophones. Sutter's French letters to Vioget still bear the multi-lingual flavor of these days, as does the contract Vioget prepared when Sutter bought the rights to the Russian Fur Company's property at Fort Ross: it was drafted in French, the only language common to both Sutter and the Russians.

This haphazard, individual French immigration would have remained the norm if it had not been for one of history's coincidences: a political uprising spread throughout France one month after James Marshal's gold discovery in California. French consul Jacques Antoine Moerenhout's report and gold samples in turn spread gold fever like wildfire when it reached the embattled nation, triggering the largest mass migration in the history of France. What was a rush to riches for the Frenchmen living along the Pacific rim meant much more for those Frenchmen living in France: it provided escape from endless riots, endemic unemployment, and the collapse of commerce and social privileges.

And so they left by the thousands. They left on the faith of guide books and advertisements that depicted San Francisco as full of palm trees and a mere hop and a skip from the goldfields. They left with dreams, and their dreams seemed to recede further and further as their ships rounded Cape Horn and they sailed closer to the Golden Gate. At last they landed in a place they described as a huge fairground, with no law, no infrastructure, no sanitation, no rhyme or reason except for gold.

Most did not even speak English. Yet they survived, and prevailed, and made a spot in the sun for themselves, a place soon called "Frenchtown," an enclave between Portsmouth Square and the Long Wharf, which was their lifeline to ships from France. Their daily struggles included many cultural ones, like the Customs Inspector who applied an old law prohibiting foreign ships from

stopping en route to California's ports, and allowed him to attach their cargos; or the postmaster who detained letters from France that remained unclaimed, since the Argonauts did not understand the way their names were pronounced in English. They lost their French identities, sometimes changed their names. It no longer mattered who they were, or what they used to do: French argonauts introduced themselves by the ship that had brought them to California's shores.

They found strength in their own number, but also in the city's extreme cosmopolitan makeup, and as San Francisco evolved from a town of tents into a grand city of bricks, they wove their way into its society, participated in its growth, and made it theirs as well. Some left a picturesque, sometimes unexpected, imprint, like José-Yves Limantour, the man who owned much of the town; like jeweler John Gordon, whom the press claimed was Napoléon's offspring; or like the Goncourt prize's very first recipient, Jean-Antoine Nau, a native San Franciscan of French heritage. Eccentric or truly hard-working, these Frenchmen, French-Canadians, French Swiss, Belgians, or Frenchmen born in foreign colonies, all had a significant impact on early San Francisco. The following pages tell their saga, a story that is a direct link to San Francisco's own past: what would the city be without sourdough bread, the Flood Building, Jack's Restaurant, Herb Caen, or the Palace of the Legion of Honor?

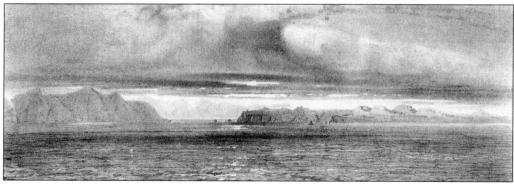

CHRYSOPYLAE, THE GOLDEN GATE. John Charles Frémont, one of the most daring and controversial of California's early explorers, named the Golden Gate (Chrysopylae in Greek), comparing it to the harbor entrance of ancient Byzantium, which was called the Golden Horn (Chrysoceras). Frémont's father was a native of France. For three years, Frémont was the assistant to French explorer Jean Nicholas Nicollet, who was employed by the war department to survey and map the country lying between the Mississippi and Missouri rivershed. Frémont had plenty of associations with French Canadians, who were often part of his retinue; with French settlers; and with French capitalists, who were heavily invested in his Mariposa mining estate in the 1860s. This view of the Golden Gate was drawn in 1837 by French artist Roumuald Georges Ménard, who sailed into the Bay under Captain Dupetit-Thouars aboard *La Vénus*. (Jacques Périlhou.)

One

EXPLORERS AND
EARLY SETTLERS

Some of the earliest information on San Francisco between 1786 and the 1840s came from French explorers, artists, scientists sailing ships outfitted like floating laboratories, and educated trading merchants.

In 1841, fresh from the acquisition of Tahiti and the Marquisas, France sent to California diplomatic attaché, Eugène Duflot de Mofras, who conducted an exhaustive exploration of California. He produced a superb report that looks like an illustrated catalog of California's early settlements and life in the "Days of the Dons."

Yerba Buena already had French residents: Victor Prudon, a French secretary to Mexican governors Jaun Bautista Alvarado and later to Mariano Guadalupe Vallejo, owned land in the village in the 1830s, as did brothers François and Nicolas Lepage. José-Yves Limantour opened a temporary store to sell the merchandise salvaged from his ship's wreck at Limantour Spit. Charles Levillain and Louis Auguste Blin lived in the village in the 1840s after jumping ship.

Two of the town's founding fathers were in fact Francophones. French war veteran of Swiss descent Jean-Jacques Vioget prepared the first survey of Yerba Buena, creating the basic plan for much of the physical layout of the city as it exists today. He also opened the first tavern on the coast of California and painted the first view of the city. Dr. Victor Fourgeaud, educated at the Ecole de Medicine in Paris, was also an early member of the small community.

When gold was discovered at Sutter's Mill, San Francisco's harbor became the only access for men and supplies to the goldfields. Its early settler did not even need to wash the gold to become instantly wealthy. By 1851, Jean-Jacques Vioget's wealth was estimated at $50,000, Dr. Fourgeaud's at $60,000.

Frenchmen already living in the Pacific within easy reach of San Francisco were also among that lucky group. Belgian argonaut Corneille De Boom, French pioneers François Louis Alfred Pioche, Jean-Baptiste Bayerque, Henri Barrhoilet, and Jean-Jacques Chauviteau became affluent businessmen who helped build and shape early San Francisco.

JEAN-FRANCOIS GALAUP, COUNT DE LAPEROUSE. Count Jean François Galaup de Lapérouse was the first non-Spanish explorer to see California and its missions. He spent 10 days documenting Monterey in September 1786 and sent a team of his best cartographers to the Presidio of San Francisco to draw up San Francisco Bay, providing a wealth of important detail on its contours at the time. (Jacques Périlhou.)

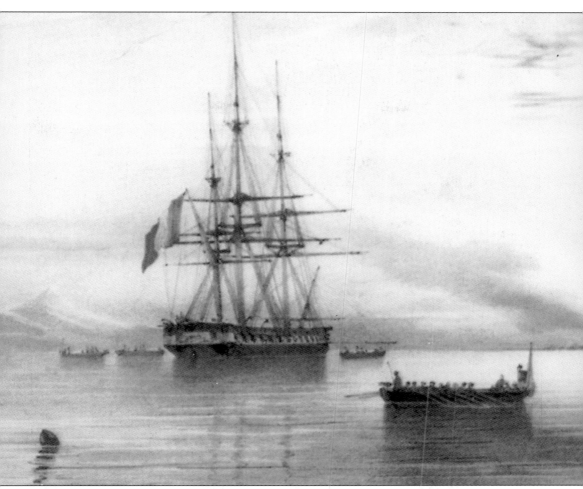

FRENCH EXPLORERS AND TRADERS. Most of the seamen who explored California's coast in the early 19th century stopped at Monterey, the territory's capital and main port. A few French seamen did make surprise appearances in San Francisco Bay starting in 1817 with French trader Camille de Roquefeuil aboard his ship *Bordelais*. The notes in his travel log contain important information on the sleepy settlement, as does the lively and exhaustive report Capt. Auguste Duhaut-Cilly wrote during his two visits to Yerba Buena aboard *Le Héros* in 1827–1828. Two Royal French Navy captains left records of their passage in the next decades: Capt. Abel Aubert Dupetit-Thouars aboard the ship *Vénus* (above), who sent three of his officers on a reconnaissance to San Francisco Bay to draw its entrance (see page 8); and Capt. Pierre Théodore Laplace aboard l'*Artémise*, who stopped at Bodega, San Francisco, Santa Cruz, and Monterey. (Jacques Périlhou.)

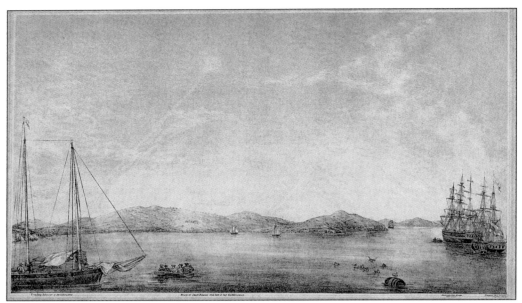

THE FIRST VIEW OF YERBA BUENA. Jean-Jacques Vioget was 16 when he fought at Waterloo. Following Emperor Napoléon's defeat, Vioget apprenticed with a French naval engineer, then went out at sea at the helm of the *Delmira* to trade with Brazil, Portugal, and Peru. By 1837, he sailed up the Pacific Coast and discovered peaceful Yerba Buena. He painted a watercolor of the small settlement when it only had two homes, one belonging to harbormaster William Richardson and one to trader Jacob Leese, both visible here. The trading schooner on the left is loaded with "California banknotes," as cowhides were called. On the right, Vioget's *Delmira* is shown moored alongside another trading vessel, a Swiss flag facetiously flying below the Peruvian one. After sailing the seas for another two years, Vioget returned and settled in Yerba Buena, renting Leese's home. (Above, Wells Fargo Museum; left, author's collection.)

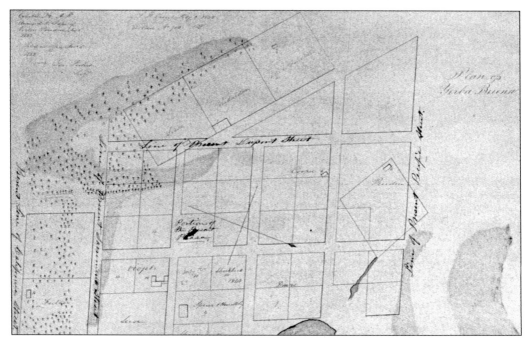

YERBA BUENA'S FIRST OFFICIAL SURVEY. Because of his engineering background, Jean-Jacques Vioget was asked to survey the settlement. In 1839, he measured it on horseback using a chain, his compass, and his sextant. Vioget created a large plaza as a focal point and standardized the existing haphazard lots. Frenchman Victor Prudon's name appears on a plot on the right. (Bancroft Library.)

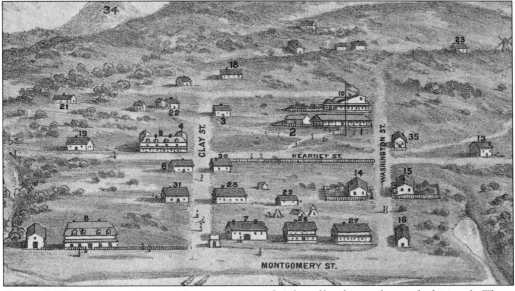

VIOGET'S TAVERN. Jean-Jacques Vioget was granted a plot of land in exchange for his work. There the seaman built the first tavern on the California coast. It doubled as a recorder's office; new grantees' names were penciled directly onto the town survey hanging in the barroom. On this 1847 drawing by Capt. W. Swasey, Vioget's house is no. 19 and his tavern no. 6. (Bancroft Library.)

AN ADVENTURER FROM ALSACE. Strasbourg-native Charles Auguste Lauff's wanderings and adventures at sea eventually brought him to Yerba Buena in 1839. Lauff discovered a village of eight adobe houses with a few other shacks built down along the water's edge. The rest of the population lived at the Presidio. He remembered: "The beach was lined with thousands of sea birds, and the bay was black with wild ducks." (Author's collection, gift of Ernest Perilhou.)

JACQUES ANTOINE MOERENHOUT. France's consul to California, J. A. Moerenhout, took his post in Monterey in 1846. He witnessed the early gold discoveries as he worked alongside local miners in the goldfields, carefully noting the gold found by Frenchmen in his jurisdiction: the Fourcade brothers, 70 pounds in large chunks; Cinquantin, 40 pounds; and an unidentified individual with 28 pounds. On some days, these lucky Frenchmen earned up to $2,000. (Abraham Nasatir.)

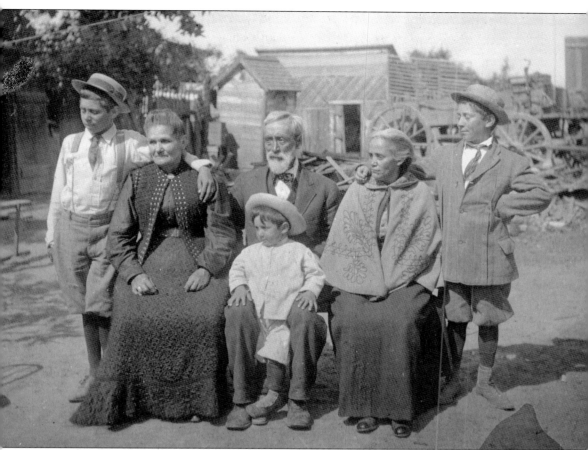

SUDDENLY WEALTHY BEYOND REASON. The Gold Rush turned San Francisco topsy-turvy and made rich men of its early citizens. The Vioget family, in particular, prospered. This *c.* 1855 photograph shows the Viogets probably before their planned departure for France. Vioget's son William, one of the boys pictured, claimed he was the first white child born in Yerba Buena. He recounted that his father had decided to put his sons in boarding school in France. The family was packed and ready to sail from San Francisco. The day before their departure, Vioget shared a farewell dinner with his friend Pierre Sainsevain in San Jose. He fell ill during that dinner and died three days later of "disease of the heart," according William. Vioget's name is nowhere to be found or commemorated in present-day San Francisco. (San Francisco Public Library.)

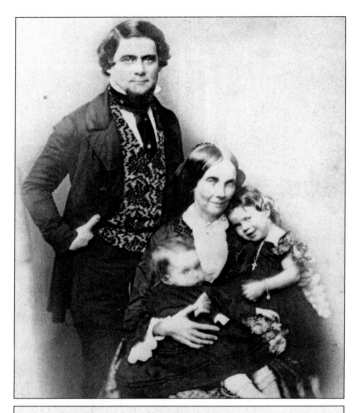

DR. VICTOR FOURGEAUD.
Born in Charleston, South
Carolina, of French parents,
educated in France, and
trained in Parisian hospitals,
this brilliant doctor headed
west across the plains with
his wife, son, and brother
in 1846. He was the first
highly qualified doctor
to settle in Yerba Buena.
He opened his office in
the village a few months
before James Marshall's gold
discovery. Like most other
Yerba Buena residents, Dr.
Fourgeaud grew rich without
even prospecting; he sold
medicine and merchandise to
the prospectors as evidenced
in the Alta California
advertisement at left. By
1856, he was elected to the
state legislature, but history
especially remembers him for
saving hundreds of California
children from diphtheria
thanks to a treatment
unknown to his colleagues
at the time. (Above,
California State Library;
below, Bancroft Library.)

MEDICINES AT WHOLESALE.

A LARGE and general assortment just received by
VICTOR J. FOURGEAUD.
San Francisco, Feb. 15, 1849. 7-tf

HATS AND CAPS.

L ATEST style of gentlemen's black hats ; also cloth
caps for men and boys. For sale by
V. J. FOURGEAUD.
San Francisco, Feb. 15, 1849.

CLOTHING.

A general assortment of clothing, consisting of fine
cloth pantaloons, do. vests, satin do. fancy do.,
cloth overalls, do. jackets, drill frock coats, do. panta-
loons, do. jackets, boys clothing, ladies' shoes. For
sale by V. J. FOURGEAUD.
San Francisco, Feb. 15, 1849. 7-tf

RUM.

I N "tin cans," put up expressly for the mining re-
gion. For sale by V. J. FORGEAUD.
San Francisco, Feb. 15, 1849.

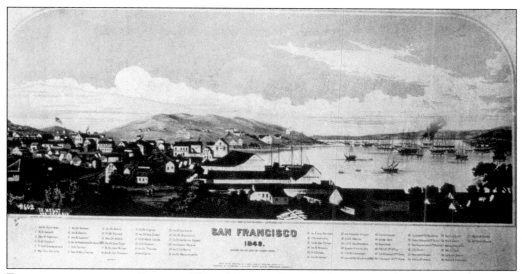

FRENCHMEN FROM THE PACIFIC. This 1849 view shows five French ships in Yerba Buena cove before the rush from France had even started. The *Olympe* had traveled via China, and the *Staoueli, Chateaubriand, Limanienne,* and *Roland* came directly from France. Rumors of gold in South American ports brought them to San Francisco with fortune seekers picked up en route, among them F. L. A. Pioche, J. B. Bayerque, and Cornelius de Boom. (Bancroft Library.)

FRENCH SEAMEN. Every French ship to San Francisco, and most foreign ones, brought French sailors ready to escape their rough labors at sea and seek their fortune. This gold-rush scene, painted by French forty-niner Ernest Narjot, depicts a young sailor (upper left) with a typical red pompon on his beret. Sailors handled labor-intensive gold panning better than most. Many went home with a fortune—if they managed to keep away from gambling halls. (Susan and James McClatchy.)

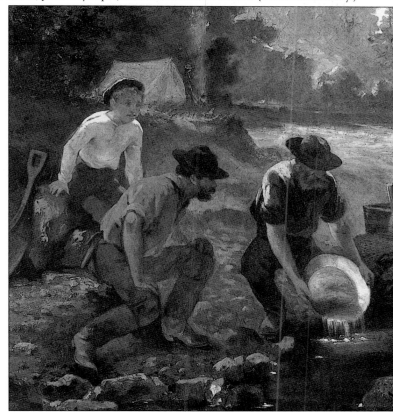

FROM CHILE: F. L. A. PIOCHE. François Louis Alfred Pioche left for Chile after studying law in Paris. In Valparaiso, he worked for the French consulate, then for a mercantile firm. He headed for San Francisco in early 1849 with a cargo of merchandise he sold at good profit. The consignment firm he started with his partner, Jean-Baptiste Bayerque, prospered and turned into a great investment institution that helped lay the foundations of the booming town. (Bancroft Library.)

FROM RIO DE JANEIRO: THEOPHILE DE RUTTE. This young French Swiss gold digger spent the years from 1846 to 1849 in Rio de Janeiro before sailing to California as the supercargo of the ship *Résolutie*. He landed in San Francisco in April 1849. An enterprising businessman, he returned home in 1856 with a fortune. (Marie Paquette estate.)

FROM LOUISIANA: FRANÇOIS PEGUILLAN. François Peguillan rushed from New Orleans and with his partner Langsman, opened a restaurant at Washington and Dupont Streets. One legend says they called it *"Le Poulet d'Or"* which was promptly mangled by English speakers into "The Poodle Dog." Another legend has it that Peguillan's wife came too, with a pet poodle brought from France, Ami. Customers would say "Let's go see the Poodle," and the name stuck. (Author's collection.)

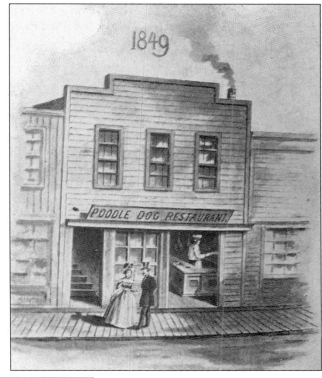

FROM LOUISIANA: JEAN-LOUIS MARTEL. The son of Marseille-born Joseph Martel, a soldier in Emperor Napoléon's Grande Armée who had emigrated to New Orleans after Waterloo, Jean-Louis Martel was himself a veteran of the war with Mexico when he reached San Francisco as a purser's clerk aboard the U.S. sloop of war *Dale*. He became a successful businessman who catered to both French and American. (Marie Paquette estate.)

FROM QUEBEC: ANTOINE CHABOT. This ingenious French Canadian headed for California with his brother in 1849. Antoine Chabot was the first to use the force of water to dissolve gold-bearing hillsides, a technique called "hydraulicking." The self-taught engineer designed the first piped-water supply systems for many young communities, including San Francisco. The "Water King" grew rich, investing in numerous novel technologies and in philanthropic enterprises like the Oakland observatory that bears his name. (Author's collection, gift of Ernest Peninou.)

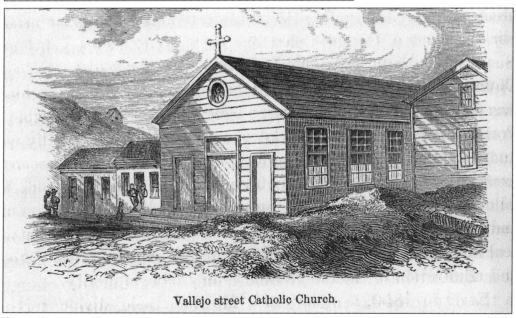

Vallejo street Catholic Church.

FROM OREGON: FATHER ANTOINE LANGLOIS. Many French Canadians took part in the Gold Rush. The city's first Catholic church was opened in June 1849 by two French Canadian priests, Fathers Jean Brouillet and Antoine Langlois, on the hill known as the North Beach. The first Mass was said in French and in English in May 1849. Mass remained bilingual until Père Langlois was replaced in 1852. (Author's collection.)

Two

GOLD RUSH ARGONAUTS

In February 1848, riots exploded in Paris only one month after James Marshall found gold at Sutter's mill in California. Consul Jacques Antoine Moerenhout's reports, gold samples, and tales of fabulous treasures found by French compatriots in California brought gold fever to France that fall. California became the subject of plays, songs, panoramas, and caricatures. The walls of Parisian streets were covered with advertisements for swift fortune in the land of gold. Immigration companies formed with the purpose of chartering vessels bound for the faraway territory.

Tens of thousands of Frenchmen sailed off for San Francisco between early 1849 and 1854. Most were men; a majority of them had never left home or sailed before. They were nicknamed "argonauts" in reference to the Greek legend that relates Jason's adventure as he sailed with his companions aboard a ship named *Argo* to search for the Golden Fleece. Like Jason and his companions, these French argonauts experienced an epic journey that forever changed their lives.

Crammed on ships that sometimes held more than 200, the passengers had to face six months of calms, dangerous storms, poor food, insalubrious quarters, boredom, and the company of men with diverse ages, fortunes, social and geographical origins, and political and religious beliefs. When a few women traveled along, the situation got even worse. Close to 25 French ships reached San Francisco between September and December in 1849, according to French consular notes and other records.

The Frenchmen's euphoria at reaching land after these long months on the ocean was short-lived as they plunged headlong into chaos. Many immigration companies disbanded before or upon arrival, robbing the new arrivals of any support as they faced bad weather, fires, and lawsuits over their ships and cargos. They gathered in camps as soon as they disembarked and reinvented themselves: Aristocrats became gardeners, and professionals turned cooks, waiters, and bootblacks.

The year 1851 can truly be called the year of the French in San Francisco; the Gallic contingent became so large that a "Frenchtown" sprouted on Long Wharf along Commercial and Dupont (now Grant) Streets. Even after the Chinese massive influx started around 1852, the French remained one of the largest foreign contingents in Gold Rush San Francisco and one of its most familiar sights.

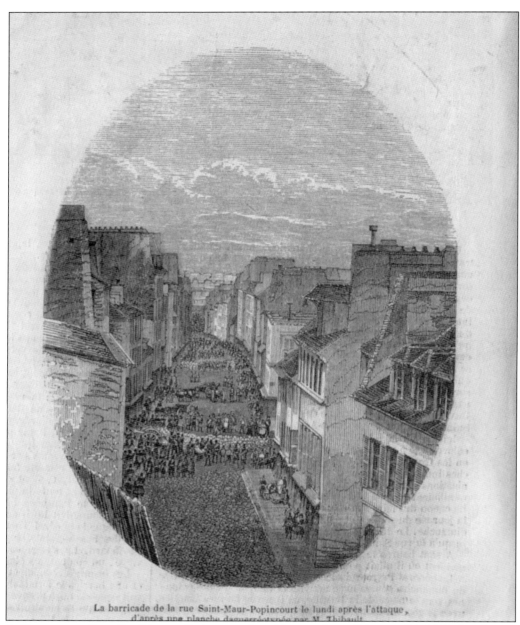

La barricade de la rue Saint-Maur-Popincourt le lundi après l'attaque,
d'après une planche daguerréotypée par M. Thibault

A BARRICADE RUE ST. MAUR. Paris was gripped by revolt on February 24, 1848, barely one month after James Marshall found gold at Sutter's Mill in California. Angry workers took to the streets again in June and were brutally repressed by government troops. Because of the slow pace of communications, it was not until the fall of 1848 that the news from California reached the French capital still deeply embattled, like the rest of the country, in political strife. This sketch was drawn from a daguerreotype by pioneer photographer M. Thibault, which recently sold (with the companion photograph showing the street empty) at Sotheby's London for $260,000. (Author's collection.)

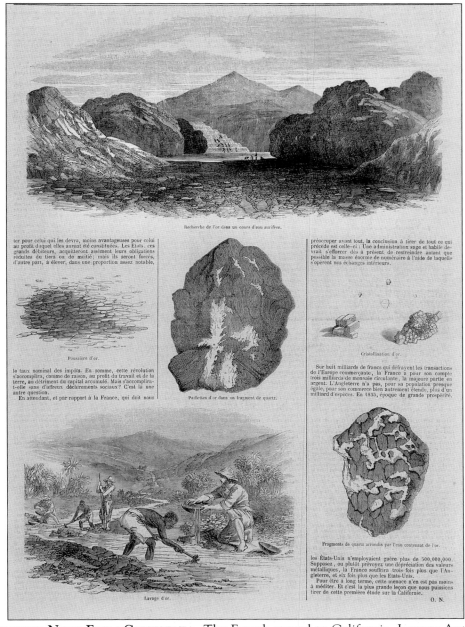

Explosive News From California. The French consul to California, Jacques Antoine Moerenhout, was among the first to announce California's gold discovery, along with press releases from New York. There was so little information on California at the time that French newspapers, especially illustrated ones, had to imagine for their readers what the country was like. This gave rise to completely unrealistic reports, like the two pages in this *L'Illustration* from 1849 that shows a California river with "convenient" steps for gold panning, as well as black slaves doing the work for white prospectors instead of Native American laborers. These same images were in fact reused in September 1858 by *L'Univers Illustré* at the time of the Frazer River Rush. (Author's collection.)

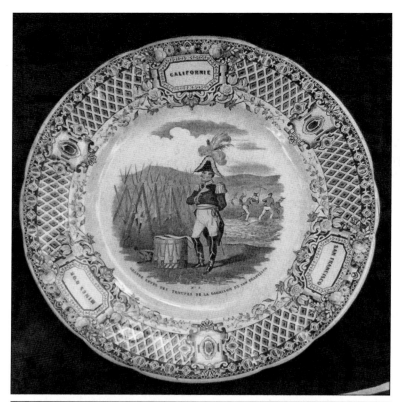

GOLD FEVER IN PARIS. Popular Parisian cartoonist Comte Amédée de Noé lampooned current events under the nom de plume CHAM. He poked fun at the French consul's reports that the governor of California's servants and soldiers had abandoned him for the goldfields. Gold fever spread at such a furious place throughout France, appearing in plays, fashion items, and even a hot-air balloon, that CHAM's cartoons were used to decorate these Limoges plates: "A California colonel reviewing the troops" (above) and "the American government finally found a foolproof way to keep soldiers from deserting for the mines" (below). (Both, author's collection.)

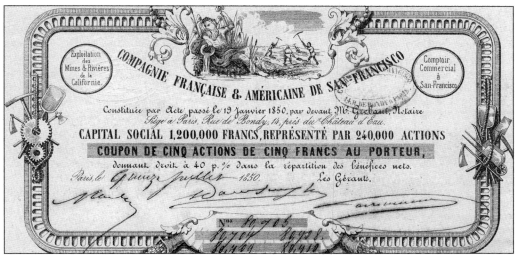

PARISIAN COMPANIES TO CALIFORNIA. The scant information that trickled from California to Paris was enough for the French to start dreaming of new fortunes. Companies were hastily formed to charter and outfit ships bound for the Pacific, to organize small battalions of would-be gold diggers, and to appeal to investors (see the company share above). More than 90 Parisian immigration companies rivaled in preparations for a safe trip and for a productive gold-digging sojourn in the goldfields. They proposed spectacular equipment, tools, and even machines that could supposedly do the work of 10 men (see the advertisement below). They did not explain how these were to be carried to the goldfields, 150 miles from San Francisco. Every one of these companies went bankrupt. (Both, author's collection.)

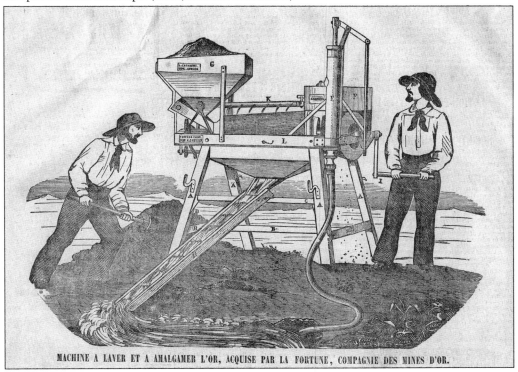

MACHINE A LAVER ET A AMALGAMER L'OR, ACQUISE PAR LA FORTUNE, COMPAGNIE DES MINES D'OR.

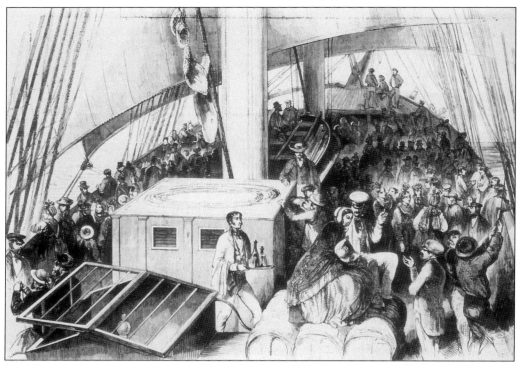

SIX-MONTH VOYAGE AROUND CAPE HORN. Sailing around Cape Horn cost $200 and took nearly six months. It was a far cry from a pleasure cruise, as this illustration in a national newspaper would have you believe. Those who chose the route via the Isthmus of Panama had to contend with many dangers, including robbers, malaria, caimans, and precipices. (Author's collection.)

SAN-FRANCESCO. -- CALIFORNIE.

En charge, au Havre, le magnifique navire de 1ʳᵉ classe à 2 ponts, le GEORGES, de 600 tonneaux, d'une marche reconnue supérieure, ayant un vaste et magnifique entrepont pour des passagers, qui seront parfaitement traités, partira le 30 avril courant, sous le commandement du capitaine Casper, qui a déjà fait ce voyage avec ce même navire.

Pour fret de passage s'adresser :

A Paris, à M. C. COMBIER, agence américaine, rue N.-D.-des-Victoires, 44 ;

Au Havre, à M. L. LAMOISSE, armateur.

THE MAGNIFICENT SHIP LE GEORGES. Ships to California were described in glorious terms by the outfitting companies, but a passenger of the *Georges* reported that they were crammed in 32 compartments stacked along two 36-foot-long alleys with no air circulating and no light. The air was filled with the foul smells from the stagnant water in the hold below, from dried meats, cod, herring, tar, oil, and "a frightening number of monstrous rats." (Author's collection.)

—La Meuse (3 mâts) allant à San Francisco—

Rôle de l'Equipage du dit navire construit en l'an 1836 à Honfleur du port de 319 tonneaux, appartenant à MM. Lemaitre & Cie, armé au Havre par le propriétaire sous le commandement du Sieur Hauret pour aller à San Francisco

[The muster roll for La Meuse, built in the year 1830 in Honfleur with a burden of 319 tons, belonging to MM. Lemaitre & Co., fitted out at Le Havre by the owner under the command of Sir Hauret, to sail to San Francisco]

Muster Roll

[Last name, first name, date and place of birth—responsibility aboard ship]

Hauret, Louis Casimir, né en 1816 à Port Cail, Manche—Capitaine

Bougny, Charles Victor, né à Caen en 1813—2e Capitaine

David, Guillaume François, né en 1813 à Gravelines, Nord—Lieutenant

Chiaune, Jean Louis Noël Désiré, né en 1811 à Dole, Ile & Vilaine—Maitre d'équipage [quartermaster]—disembarked in San Francisco on 14 September 1849 with full pay

Le Bailly, Louis, né en 1798 à Fontenay—Cuisinier [cook]

Thébault, Louis François Augustin, né en 1807 à Fleurac, Charente*

L'Hostis, Guillaume Marie, né en 1825 à Guilers, Finistère—Novice*

Legrand, Pierre Désiré, né en 1823 à Saint-Servan—Matelot**

Metras, . . ., tombé à la mer le 31 mai 1849 [lost at sea 31 May 1849]

Guérin, Camille Louis—Matelot**

Reforzo, Aurélien Michel, 1810—San Remo

Crette, Jean-Charles, né en 1821 à Paris—Matelot**

Castel, Yves Jacques, né en 1807 à Morlaix—Matelot*

Bigot, Jean-Marie, né en 1821 à Greville—Matelot [deserted 5 October 1849]

Belon, Honoré, né en 1819 à Cagnes, Var—Matelot*

Delpierre, L. S. Fois, né en 1831 à Boulogne—Novice

Tardif, Léon Baptiste—né en 1832 en Mayenne—Mousse*

Burel, Léon Paul, né en 1831 à Paris—Mousse

Hébert, Guillaume—Matelot—deserter from French ship Angelina*

Ducassou, Jeune, disembarked in San Francisco 13 September 1849

*deserted in San Francisco 18 September 1849
**deserted in San Francisco 20 September 1849

Passengers

[Last name, first name, age—place of birth—place of residence—occupation]

Coche, Louis Jean Baptiste, 28 ans—Guillaumes, comté de Nice—réside à Marseille—journalier [laborer]

Toche, Ambroise, 29 ans—Guillaumes, comté de Nice—réside à Marseille—journalier

Demarquet, Louis Marie, 36 ans—Paris—réside à Paris—doreur sur argent [silver gilder]

Don, Jean, 28 ans—Marseille—réside à Marseille—tapissier [upholsterer]

Magalon, Jean-Baptiste, 40 ans—Guillaumes—réside à Marseille—cafetier [café owner]

Laisnel, Jean-Benjamin, 43 ans—originaire de Lignères, Cher—réside à Paris—cuisinier [cook]

Hain, Victor Jules, 42 ans—originaire de Crony, Oise—réside à Paris—négociant [merchant]

Haessler, Charles Auguste Henri, 23 ans—originaire de Zurich—négociant

Gautier, Marie Nicolas, 47 ans—Paris—réside à Paris—tourneur en cuivre [copper turner]

Cadazel, Pierre Hippolyte, 17 ans 1/2—originaire de Paris—réside à Paris—commis [clerk]

Bellange, Louis Alfred, 35 ans—originaire de Meulun—réside à Paris—commis

Collette, Théodore Henry, 23 ans—originaire de Dieppe—réside à Dieppe—tanneur [tanner]

Eudes, Alfred Antoine Emile, 33 ans—Paris—réside à Paris—courtier de commerce [commercial broker]

Baudry, Charles Emmanuel, 28 ans—originaire de Paris—réside à Paris—papetier [stationer]

Bennert, Albert, 22 ans—originaire de Mulhouse—réside au Havre—pharmacien [pharmacist]

Archambault, René Marie, 53 ans—Nantes—réside à Montmartre—raffineur [refiner]

Crépin, Henri, 32 ans—originaire de la Marne—réside à Paris—marchand de vins [wine merchant]

Bernier, Casimir, 39 ans—originaire de la Ferté Milon, Aisne—réside à Paris—cocher [coachman]

Pache, Guillaume, 40 ans—originaire de Sardaigne—rentier [person of independent means]

Lefebvre, Léon Pascal, 38 ans—originaire de Rouen—réside à Petit Couronne—rentier

Morel, Louis Xavier, 51 ans—originaire de Pontorson—réside à Paris—pharmacien

Perreau, Alexandre, 40 ans—originaire de l'Yonne—réside à Paris—négociant

Pauvet, Bruno Fois, 38 ans—Mezel, B. Alpes—réside à Paris—marchand de tapis [rug merchant]

Guiguandon, Barthélémy, 47 ans 1/2—Ambert, Puy de Dome—réside à Paris—bijoutier [jeweler]

Roisin, Eugène—33 ans—originaire de Granville—réside à Paris—clerc d'huissier [court clerk]

Pingeon, Charles, 28 ans—originaire de Chalssong (Ain)—réside à Paris—rentier

Leboulanger, Félix Ferdinand, 44 ans—originaire de Croixmaure

Carré, Edmond, 22 ans—Paris—réside à Croixmaure—peintre tapissier [painter-upholsterer]

Cherblanc, Louis, 50 ans—originaire de la Loire—réside à Montmartre—rentier

Frossard, Joseph, 49 ans—originaire de Dole—réside à Passy—propriétaire [property owner]

Binet, Alexis Hermeline, 25 ans—La Ferté (Sarthe)—réside à Paris—commis de marchand [shop assistant]

Brachais, Pierre Napoléon, 39 ans—Croixmaure (Seine Inférieure)—boulanger [baker]

Auradou, Jean, 43 ans—Castillionerre (Lot & Garonne)—réside à Paris—bottier [bootmaker]

Auradou, Jules Antoine, 16 ans—Paris—réside à Paris—peintre en décors [painter-decorator]

Guiot, Alexandre Charles Auguste, 46 ans—Saint-Brieux—réside à Paris—ingénieur civil [civil engineer]

Dittrich, Gustave Wilhelm, 33 ans—originaire de Berlin—réside à Paris—négociant

Lassimonne, Jean, 28 ans—Sainte Badegonde (Charente)—réside à Paris—bonnetier [hosier]

Orlowski, 49 ans—originaire de Pologne—réside à Paris—bonnetier

Brunet, Antoine, 33 ans—Bauche—réside à Paris—marchand de nouveautés [dry goods merchant]

Sallandrouze, Eugène, 37 ans—originaire de Neuilly—réside à Paris—marchand de tapis

Bellec, propriétaire

Gosselin, avocat [attorney]

Josse, manœuvre [manual laborer]

Diettrick, négociant

Savard, bijoutier

Lessercq—vrai nom [real name] Lepercq, Henri—32 ans—Quesnoy—Paris

Sadou, épicier [grocer]

Grados, Antoine—26 ans—Féreux, Paris—bijoutier

Pache, Neveu—épicier

D'Etroyat, François Ernest—commis voyageur [commercial traveler]—embarqué à Lima

FIRST SHIP DIRECT FROM FRANCE. *La Meuse,* an old, 500-ton, three-masted whaler named for a French river was the first argonaut ship to leave France for California on March 22, 1849. With 41 passengers aboard—and not a single woman—she reached San Francisco on September 14, 1849, with 19 extra passengers picked up at Callao after a 173-day voyage. Most of her crew deserted within a week of her arrival. Yet unlike many French ships that ended up buried in the mud of the Bay in what was dubbed "French Row," *La Meuse* sailed to Hawaii on January 1, 1850, with only four crewmen aboard, picked up native seamen on the island, went on to Asia where the captain purchased a cargo, and was within sight of France, when an unusually powerful winter storm wrecked her. All crewmen and all but one passenger were saved. (French Maritime Archives.)

FRENCH FORTY-NINER JULES AURADOU: *LA MEUSE*. Paris-born Jules Auradou was 17-years-old when he landed in San Francisco on the ship *La Meuse* with his father, a former hotelier in Paris. Together with their cousin Jean Pache, the ship's carpenter, and a few passengers, they set out to make and sell charcoal, then headed up to the placers of the American and Yuba Rivers where they washed gold. (Author's collection, gift of Ernest Peninou.)

FRENCH FORTY-NINER ALPHONSE DELEPINE: *L'EDOUARD*. Twenty-five-year-old law student Alphonse Délépine joined one of the first Parisian immigration companies bound for California and sailed to San Francisco aboard *l'Edouard*. He was a peddler, laborer, cook, baker, launderer, dishwasher, brick-maker, and miner before earning a fortune as a gardener. After selling his garden, he opened a consignment firm in San Francisco in 1851, only to lose it all in a fire. (California State Library.)

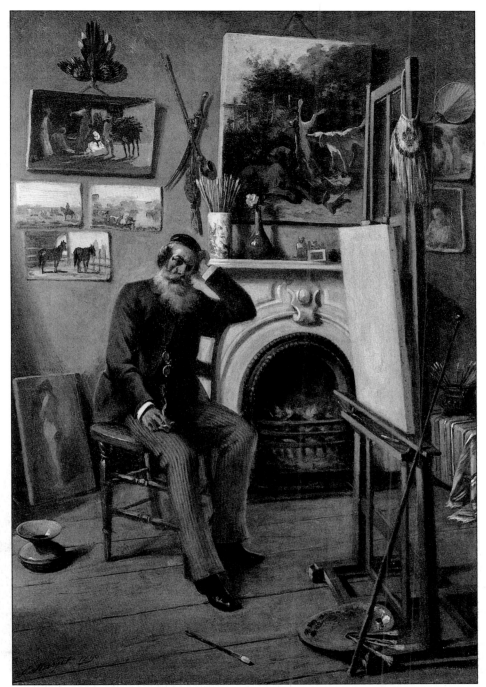

FRENCH FORTY-NINER ERNEST NARJOT. Ernest Narjot, a native of Saint-Malo, had some training in art when he reached San Francisco in the fall of 1849. After gold panning at Foster's Bar, he joined the ranks of a French filibustering expedition to Mexican Sonora in 1851. The expedition failed. Narjot bought a ranch, married a local Sonoran, and returned to San Francisco with his family in the 1860s. He became one of California's foremost painters. (Garzoli Art Gallery.)

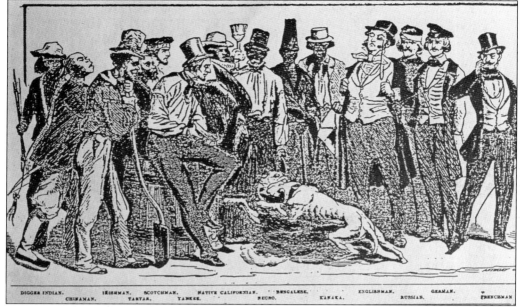

DIGGER INDIAN. IRISHMAN. SCOTCHMAN. NATIVE CALIFORNIAN. BENGALESE. ENGLISHMAN. GERMAN.
 CHINAMAN. TARTAR. YANKEE. NEGRO. KANAKA. RUSSIAN. FRENCHMAN

COSMOPOLITAN SAN FRANCISCO. This sketch from an 1854 *California Mercantile Journal* illustrates the colorful garb of the crowd that walked the streets of Gold Rush San Francisco. The ever-whittling Yankee (center) is shown in casual "sportsman" attire and the Frenchman (far right) is the dandy in an impeccably cut suit from Paris. (Author's collection, gift of Ernest Peninou.)

FRENCH CAMP. San Francisco winters were particularly difficult, as French forty-niner Jean Montes reported, "We generally get two days of good weather to eight of rain, which is why we are lodged in some fashion in our miserable tents; we are for the most part quite wet, and we lie down on mattresses soaked with water." This sketch was drawn by Alsace-native Jacques Joseph Rey, cofounder of the successful lithographic company Britton and Rey. (California Historical Society.)

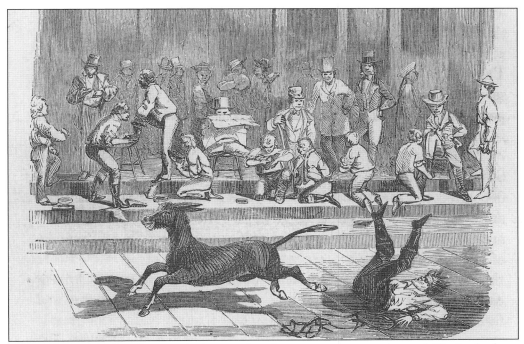

FRENCH SHOEBLACKS. Painters, bakers, and gardeners were in great demand. Cooks, barbers, gamblers, and musicians always found work. The rest, whether of common or noble birth, had to turn to odd jobs, many to bootblacking. One an inventive Frenchman used a blunt knife with a blade of gold to scrape boots and charged $1 per shoeshine, double the going rate. (Author's collection.)

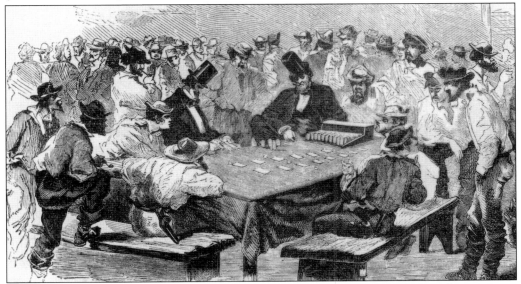

FRENCH GAMBLERS. Gambling was another common survival activity among the French contingent. In March 1851, French consul Patrice Dillon deplored that Frenchtown had become the general headquarters for the French gambling industry. French argonaut Jules Rupalley also chronicled a gambling saloon during his adventures in California. (Wells Fargo Museum.)

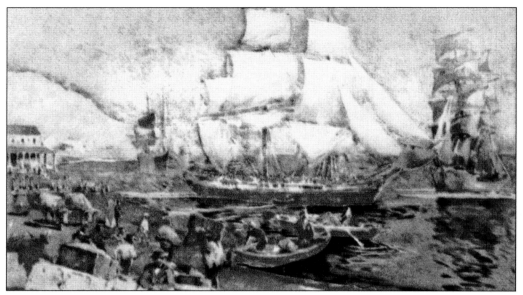

THE FIRST *VILLE DE PARIS*. Emile Verdier crossed the Isthmus of Panama with valuable merchandise in mule packs, chartered a brig he named *Ville de Paris*, and entered the Golden Gate in the spring of 1850. His cargo sold so quickly off the ship's deck that he traveled back to France and made a second voyage in 1851. Verdier opened a store at 334 Clay Street that he also named Ville de Paris. (Author's collection.)

FRENCH BUSINESSES. French businesses started to sprout everywhere to cater to the flood of French emigrants. This 1851 view of Montgomery Street shows the store, kept by prominent French merchants Sabatié and Maubec.who imported French goods, including Bordeaux wines, reputed to prevent scorbut, a dangerous illness caused by lack of vitamin C, common among sailors on long trips. (California Historical Society.)

FRENCH COLUMNS IN SAN FRANCISCO'S DAILIES. Sponsored by French importer Jean-Jacques Chauviteau, the Marquis Jules de France published a handwritten French newspaper in 1850. By 1851, French columns appeared in several of San Francisco's newspapers. Argonauts Albert Bénard, Etienne Derbec, and Ernest de Massey each published French news and advertisements in the columns of local newspapers. (California State Library.)

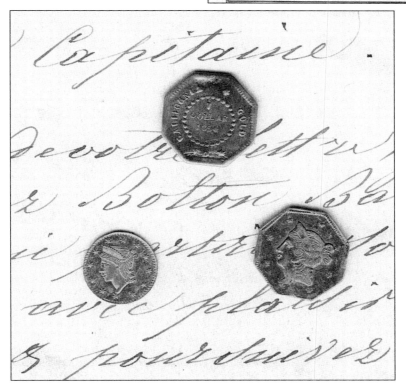

FRENCH JEWELERS. American money was scarce in the early Gold Rush days. Before the U.S. Mint was established in 1854, banking companies resorted to coining their own money. Several French jewelers, including Pierre Frontier, Eugène Deviercy, Antoine Nouizillet, and Isidore Routhier, were instrumental in creating these miniature, pure gold coins that measured a half-inch or less. (Bob Chandler.)

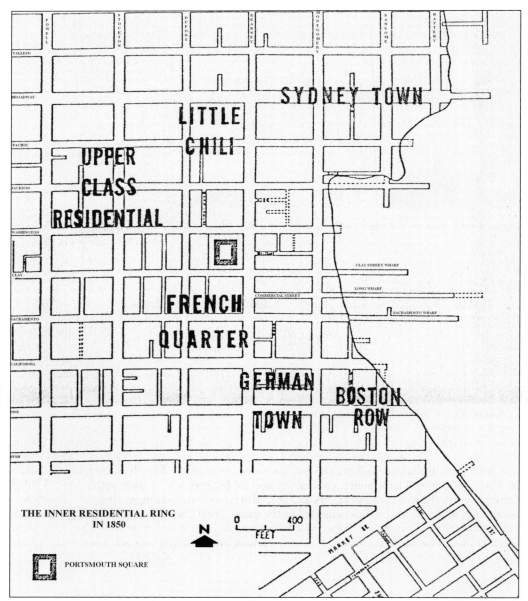

THE INNER RESIDENTIAL RING
IN 1850

N

0 400
FEET

PORTSMOUTH SQUARE

FRENCHTOWN. The French at first settled all over San Francisco, but by 1851, although there were still Frenchmen and French businesses in every section of San Francisco, they were most numerous in the vicinity of Portsmouth Square, especially around the district that soon came to be known as "Frenchtown" around Montgomery, Dupont, and Commercial Streets. Business directories for 1851–1853 show that there were as many Frenchmen on Dupont Street as there were on Commercial Street, a brand new artery cut in July 1850 as an extension of Long Wharf. Commerce with France was active and lucrative around the wharf where French ships landed goods. (University of California, Berkeley.)

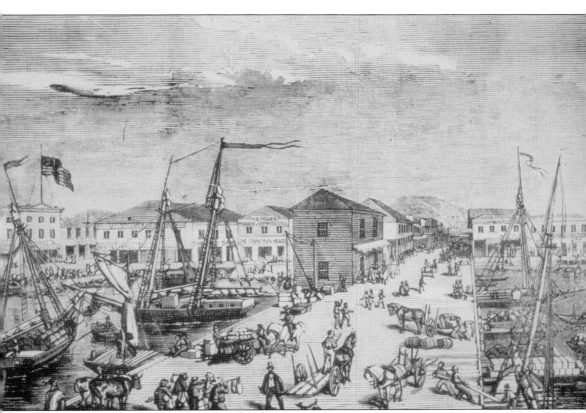

COMMERCIAL STREET AND LONG WHARF. Since Commercial Street was much shorter than Dupont Street, the French presence was more concentrated and much more noticeable, as described in this June 29, 1851 article in the *Alta California*: "Pass through Commercial Street, the residence of the daughters of 'La Belle France,' of an evening. The spacious saloons on each side are lighted brilliantly. Behind the bars are seated very pretty French women who circulate between the Bar and lansquenet, or rouge et noir table, from which issue with a very decided French accent, the words 'red wins,' 'six and ace,' 'thirty-one,' unmeaning entirely to an 'outsider,' but fraught with interest to those engaged in the game. Enter one of the more quiet saloons. You will find a party of Frenchmen seated at a table, drinking claret and jabbering together of their loved France. The street is French, decidedly French, and in it you may see a miniature of the great city of 'La Grande Republique.' " (San Francisco Maritime Museum.)

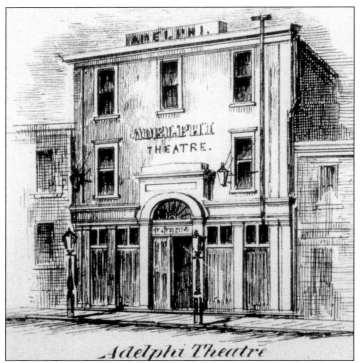

ON DUPONT STREET: THE ADELPHI THEATER. Originally located on Commercial Street, then rebuilt on Dupont Street, the Adelphi Theater was where Alexandre Dumas fils's play *La Dame aux Camélias* premiered in San Francisco, as did Victor Hugo's *Marie Tudor*. French businessman and former actor A. Tallot financed the reconstruction of the Adelphi Theater after it was destroyed in the fire of May 4, 1851. The architect and decorator was M. Duchesne. (Bancroft Library.)

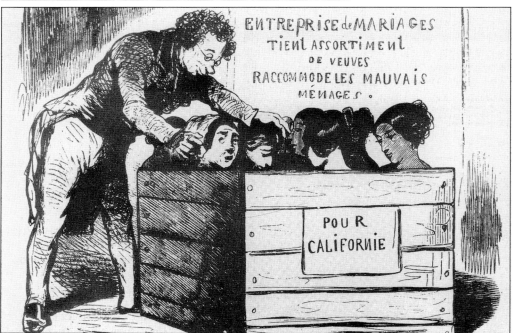

FRENCH WOMEN. Whether they appeared at a gambling table like Madame Jules, in a play like Lucienne Carpentier, in a concert like Madame Planel, or running a business like Françoise de Saint-Amant, the French women bold enough to head for San Francisco were universally admired, adored, and showered with gold. CHAM did not miss out on their popularity. (Author's collection.)

ON COMMERCIAL STREET: LA POLKA.
Canadian gold seeker William Perkins described
the Polka Saloon as one of the largest and
most crowded of the city: "Gold and silver and
rich crystal of every form combine to make it
attractive, as well as the beautiful French girls,
elegantly dressed, serving the liquor." Owner
Charles Barrhoilet arrived in San Francisco
from Chili with his family in 1849. His partner,
Henri Carrière, was a former weight lifter in a
French circus. (California Historical Society.)

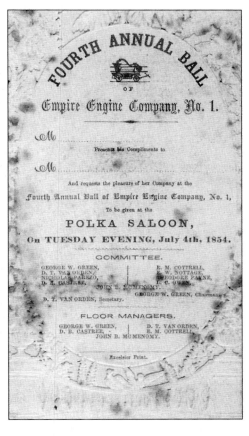

MINEUR'S RESTAURANT

N° 531 et 533 RUE COMMERCIAL, San Francisco.

(Maison Fondée en 1849.)

Succursale, 737 rue Market, vis-à-vis de Dupont, S. F.

Abrégé de la Carte.

Soupe.

		Poissons.	
Au poulet	10c	Saumon	10c
Aux huîtres	10c	Poisson de Roche, Merlan	10c

PLATS FROIDS DE TOUTE ESPÈCE.... 10c.

Entrées.

Fricandeau à l'oseille	10c	Bœuf à la mode	10c
Rognons de veau ou de mouton	10c	Pieds ou têtes de veau	10c
Fricassée de poulet	20c	Lapin ou lièvre	10c
Rognons sautés	10c	Cervelles au beurre noir	10c

Légumes.

Choufleurs... 10c — Haricots... 10c — Asperges... 10 — Salades... 10c

Bouillis.

		Rôtis.	
Jambon	10c	Bœuf ou foie	10c
Bœuf salé aux choux	10c	Veau ou mouton	10c
Porc salé	10c	Poulet ou dinde	25c

3 plats de 10 cents, à une personne, 25 cents.

Cuit sur Commande.

Filet et contre-filet.. 25c — Sirloin aux pom.. 15c — Filet aux pom..	20c	
Beefsteak à l'Espagnol.. 10c — Côtelettes de porc ou de mouton..	10c	
Boudin...10c — Saucisses frites...10c — Rognons...10c — Tripes	10c	

Œufs.

à la coque ou sur le plat	20c	Omelette de 3 œufs	20c
au beurre noir	20c	½ œufs et jamb, 20c; 3 œufs-jamb.	25c

Puddings et Tartes.

Tapioca	10c	Tasse de crème	10c	Cranberry	5c
Sagou	10c	Pommes ou pêches	5c	Beignets aux p..	10c

Fruits et gâteaux de toute espèce.... 10c

Vins.

Vins de table, b. 30c; ½-b. 15c; verre, 10c; Vin blanc de Cal. 20c; ½-b.	10c		
Pouillac	50c	Sauterne ½ bouteille	50c
"Miner's Restaurant"	75c	St-Christoly, la bouteille	$1 00
Café noir et Cognac	15c	Verre de bière	5c

☞ *Ouvert de 5 heures du matin à 10 heures du soir.* ☜

P. B. BERGES & Cie, Propriétaires.

ON LONG WHARF: LE MINEUR'S. This
early restaurant was one of the three
cornerstones of Frenchtown, along with
the Adelphi Theater and the Polka
Saloon. As the bay was filled, and
wharves became streets, Long Wharf
turned into Commercial Street and Le
Mineur's address, which was still on Long
Wharf in 1856, changed to 531 and 533
Commercial Street, the address given on
this 1879 menu. (Author's collection, gift
of Ernest Peninou.)

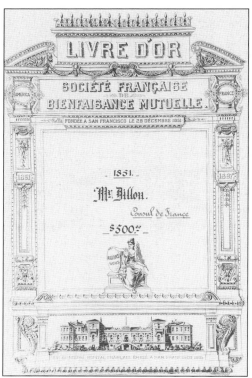

SAN FRANCISCO'S FRENCH HOSPITAL. In early December 1851, the tragic death of a French miner greatly moved the French population. French businessman Eugène Delessert called for the immediate creation of a French Mutual Benevolent Society, the first health maintenance organization (HMO) ever established. French consul Patrice Dillon symbolically made the first of many donations recorded in the society's *"Livre d'Or"* or "Golden Book." (French Mutual Benevolent Society.)

MAISON DE SANTÉ. The French Mutual Benevolent Society built its third hospital on Bryant Street in 1870 at a cost of $7,195. This large brick Maison de Santé had a water tower on its side, was designed by Prosper Huerne, and was drawn by Swiss artist Paul Emmert. According to its archives, the hospital accommodated 60 patients and had a superintendent, two male nurses, and a cook on its staff. Members paid $2 a day for a bed, non-members $4. (Bancroft Library.)

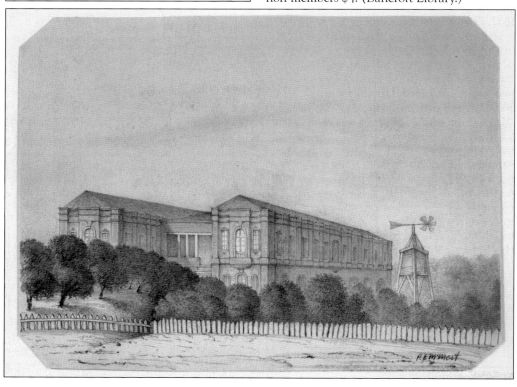

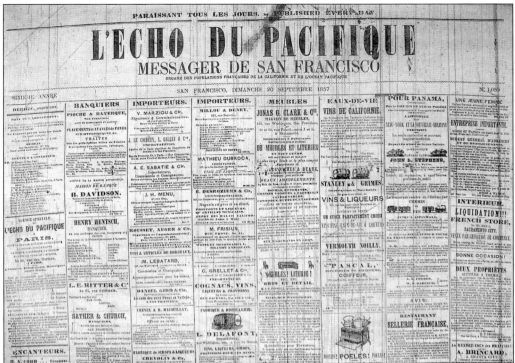

L'ECHO DU PACIFIQUE. In June 1852, Etienne Derbec, formerly a typographer for the *Journal des Débats* in Paris, published the first issue of this newspaper, which remained the French community's principal newspaper until 1865. His alleged Southern sympathies during the Civil War and Imperial Mexican sympathies for Maximilian's regime caused him to lose his offices and newspaper to vandalism. Because the U.S. military made San Francisco's vandalized papers change their names, Derbec promptly came out with the successor to *l'Echo*, the *Courrier du Pacifique*, which was published for 25 years. (Both, Bancroft Library.)

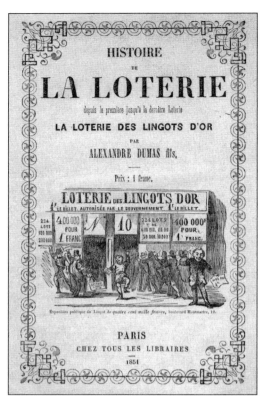

A PHILANTHROPIC OPERATION. A lottery with a golden ingot for its main prize was organized in Paris in 1852. It was humanitarian in purpose: to give free passage to California to thousands of Frenchmen ruined by the country's political and economic chaos. Alexandre Dumas fils, author of *La Dame aux Camélias*, produced a "History of the Lottery" brochure to advertise the operation and officially endorse the lottery. (Jacques Périlhou.)

A POLITICAL TOOL. Signing up for passage was voluntary, but the Paris Prefect of Police was the man in charge of selecting the passengers who would eventually board the ships bound for California. The operation turned into a clever way for the newly elected president Louis Napoléon Bonaparte (and the self-proclaimed emperor in December 1851) to get rid of troublesome political activists. (Author's collection.)

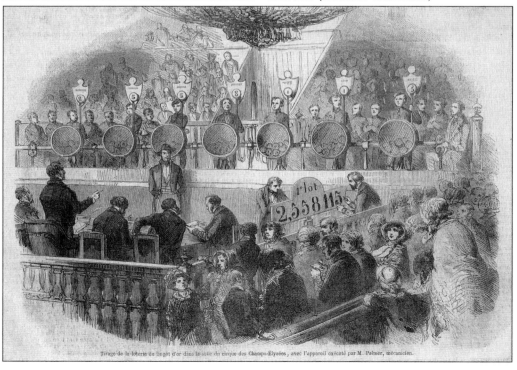

Tirage de la loterie du lingot d'or dans la salle du cirque des Champs-Élysées, avec l'appareil exécuté par M. Palmer, mécanicien.

FREE PASSAGE TO CALIFORNIA. Between February 1852 and May 1853, more than 3,000 French men and women were shipped to San Francisco free of charge aboard 17 specially outfitted ships. Consul Patrice Dillon wrote to his superiors in Paris: "What am I to do with this mass of human beings thrown all of a sudden in the middle of a town and of a population whose language and customs are totally foreign to them?" (Préfecture de Police, Paris.)

Départ Gratuit pour la Californie

Contrôle Nominatif des Emigrants (Ménages) indiquant leurs âge, sexe, profession, lieu de naissance et demeure. (130 individus partis, dont 4 enfants au-dessous de 7 ans) du 13 9bre 1851.

3e Départ, (Ménages)

le Courrier de l'Inde

ARRIVAL OF FRENCH -- Yesterday our population received quite an important accession from France. The "Courrier of the Indies" arrived, bringing ninety-six passengers, who are part of the 5000 that drew prizes in the lottery of the Golden Ingots. Forty-two of the passengers were females. All forming families of respectability, who have made up their minds to settle permanently in our State. We understand that four thousand three hundred are yet to come from the same source. Between six and seven hundred having already arrived.

HYPPOLITE BOVEAU, a Frenchman, fired a pistol in the street and did not know any better. Discharged.

THREE FRENCHMEN with unpronounceable names were found very noisy on Pacific Wharf and fined $5 each.

DRUNK. Bonbon, a fierce whiskered Frenchman who recently arrived here on the Gold Lottery arrangement, was found so very drunk on Commercial st. that he was totally oblivious of all that was going on in this sublunary hemisphere. He was sent down 24 hours to allow his coppers to cool, and promised to be more careful in the future.

SAN FRANCISCO'S "INGOTS." Some of these indigent and disoriented French newcomers—quickly dubbed "Ingots"—fell into episodic drunken and disorderly behavior as San Francisco's 1852 police court columns (left) reveal. Others quickly made a name for themselves, including poet Pierre Cauwet; journalist Léon Chemin, who published *Le Phare*; printer Louis Albin; and 16-year-old Isidore Boudin, who founded a French bakery on Dupont Street with his family. (Bancroft Library.)

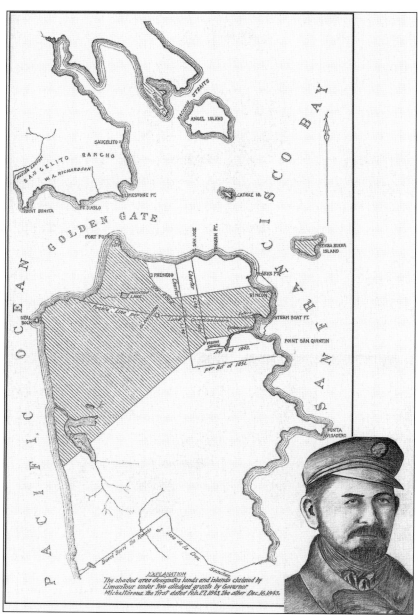

THE LIMANTOUR CLAIM. In February 1853, Joseph Yves Limantour, a sea captain from Brittany and an early resident of California, appeared before the land commission appointed to review and confirm the validity of land titles issued during the Mexican era. He presented a claim for 47 square leagues of land, close to two-thirds of the city of San Francisco—all the land south of California Street, plus the islands of Alcatraz, Yerba Buena, and the Farrallones, and the Tiburon peninsula. The commission confirmed the claim's authenticity in 1854. Panic followed among the 50,000 San Franciscans now living on his land. Hundreds "bought back" their lots from the Frenchman. The stakes were such that the case was reopened the same year. The title was ultimately rejected on November 19, 1858, after high legal drama in the courts. Convicted of fraud, Limantour returned to Mexico City and finished his life quietly as a rich man. (Z. S. Eldredge; Jean-Pierre Barbier.)

42

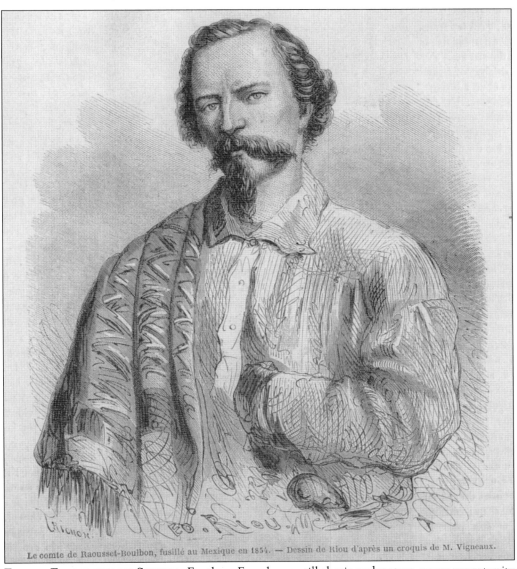

Le comte de Raousset-Boulbon, fusillé au Mexique en 1854. — Dessin de Riou d'après un croquis de M. Vigneaux.

FRENCH FILIBUSTERS TO SONORA. For those Frenchmen still chasing adventure, a new opportunity appeared in the gold mines of Sonora, Mexico. Rumors of rich gold and silver mines in Apache territory seemed to suddenly fascinate the disillusioned French miners. The Mexican government did not allow armed Americans on its territory, but it made an exception for Frenchmen. Or so it seemed. Three expeditions of French miners and colonists led by flamboyant French aristocrats, the Marquis de Pindray and Comte de Raousset-Boulbon, brought hundreds of Frenchmen to Sonora, Mexico, among them artists, doctors, lawyers, accountants. The adventure turned sour when the Mexican government, worried about the presence of these French armies on its territory, reneged on most of its promises. The marquis was assassinated, and the count was executed in Guaymas in August 1854. San Francisco's French and Mexican consuls were put on trial for abetting these filibustering expeditions on California soil. Raousset's Napoleonic stance on this sketch is a reminder that these expeditions may have encouraged the French-backed Maximillian regime of the 1860s. (Author's collection.)

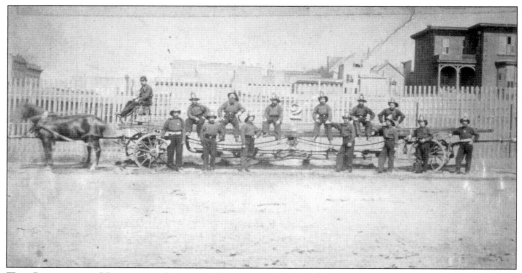

THE LAFAYETTE HOOK AND LADDER COMPANY. As San Francisco grew, a new elite developed among the young men of the city who organized volunteer companies to fight the flames that regularly engulfed the city. In September 1853, the Lafayette Hook and Ladder Company No. 2 was organized by H. A. Cobb, Emile Grisar, and a number of French citizens of San Francisco. (California Historical Society.)

THE UNIFORM OF PARISIAN FIREMEN. Membership in one of these fire companies was an honor, and admission was not easy. The equipment was a matter of pride for these volunteers. The Lafayette company bought its own California-made fire truck, and Emperor Napoléon III sent uniforms similar to those of Parisian firefighters, right down to the helmets that showed off "Saprs. Pompiers de San Francisco" on their emblems. (Wells Fargo Museum.)

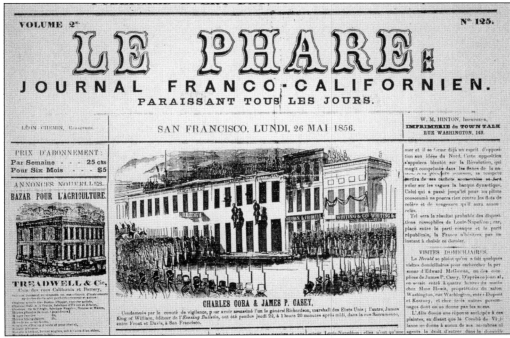

THE FRENCH AND THE VIGILANCE COMMITTEES. A large group of French entrepreneurs sided with public order when San Francisco's lawlessness became a problem in 1851. Several, like early settler Jean-Jacques Vioget, were present at the meeting that gave birth to the first vigilance committee. French commission merchant Eugène Delessert became the committee's treasurer. Immigrant Léon Chemin published the news of vigilance committee hangings in the May 26, 1856, issue of his newspaper *Le Phare* (above.). (Above, author's collection; below, California State Library.)

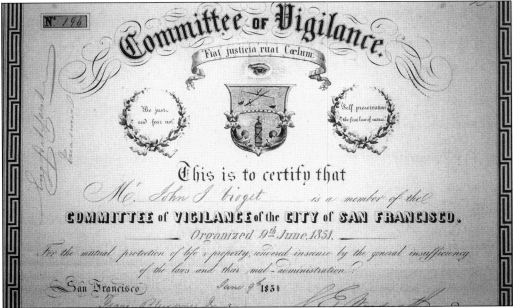

MERYON'S ETCHING OF SAN FRANCISCO. In 1856, F. L. A. Pioche commissioned French artist Charles Meryon to execute a panoramic view of San Francisco from five daguerreotypes sent to

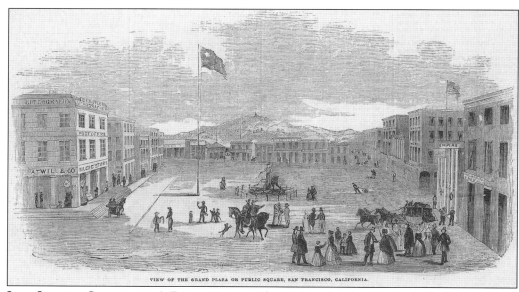

VIEW OF THE GRAND PLAZA OR PUBLIC SQUARE, SAN FRANCISCO, CALIFORNIA.

JEAN-JACQUES CHAUVITEAU'S PLAZA DESIGN. This Parisian banker who landed in San Francisco in early 1849 became a successful commission merchant and banker, and took an active part in the life of his adopted town. In 1854, Chauviteau hired an architect and an attorney to create a

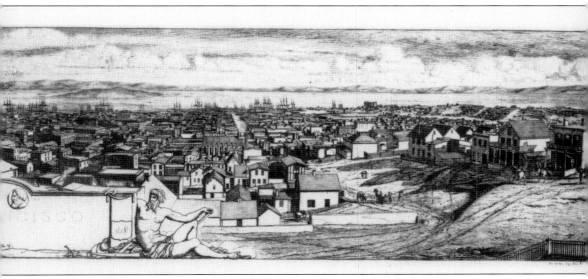

him in Paris. The portraits and initials of Pioche and his partner, J. B. Bayerque, appear on the central panel. (Garzoli Art Gallery.)

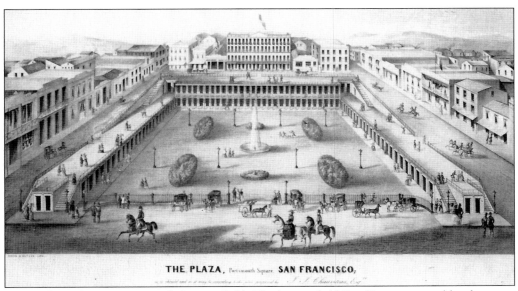

THE PLAZA, Portsmouth Square, SAN FRANCISCO,

proposal to redesign Portsmouth Square (left). The heart of old San Francisco would today sport covered, Parisian-style shopping galleries, as shown above if city hall had accepted his plan. (Left, author's collection; right, Bancroft Library.)

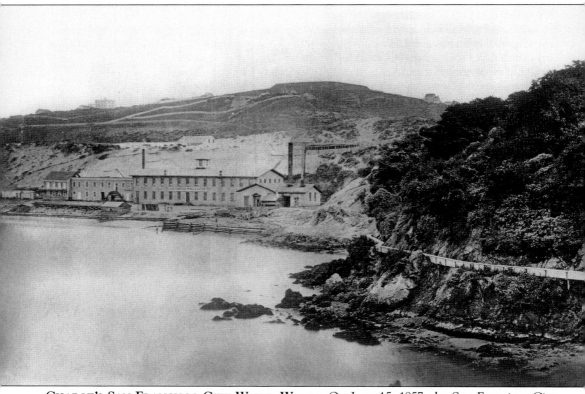

CHABOT'S SAN FRANCISCO CITY WATER WORKS. On June 15, 1857, the San Francisco City Water Works was incorporated with Antoine Chabot, John Bensley, and A. W. Von Schmidt as its first trustees. According to historian Sherwood D. Burgess, Chabot designed a water system using a wood flume with a gradual slope that would carry water from Lobos Creek along the shore of the Golden Gate and bay to a two-million-gallon reservoir in North Beach near the foot of Taylor Street. By September 1858, San Franciscans saw the first water flow through the main pipes into their city. They no longer had to keep fire buckets filled and at the ready in their homes, and water carts soon became a thing of the past. Once the system launched, Antoine Chabot and his brother Remi turned to other projects in Oakland, where the family eventually settled. (San Francisco Public Library.)

NOTRE DAME DES VICTOIRES. Abbé Dominique Blaive, a former captain in the French army, first suggested a truly French church in San Francisco in 1855 during festivities to honor the French victory in Crimea. The following spring, French financier Gustave Touchard helped Blaive buy an Anabaptist temple on Bush Street. Once slightly modified, the building was consecrated by Bishop José Sadoc Alemany on May 4, 1856, as Notre Dame des Victoires to commemorate all French victories. (Fr. E. Siffert.)

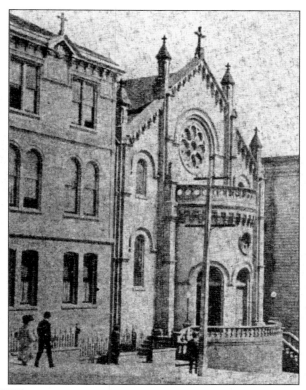

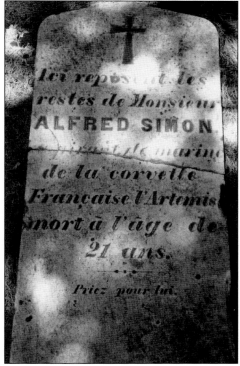

FRENCH TOMBS AT MISSION DOLORES. Quite a few early French residents of San Francisco were buried in Mission Dolores's cemetery, among them Eugène Lhôte, Adolphe Cheminant, Adèle Rondel, and Lt. Alfred Simon of the ship l'Artémise. By 1880, because of the growth of the mission neighborhood, the State of California prohibited further burial at the mission's cemetery. (Author's collection.)

49

THE FRENCH COMMUNITY IN THE LATE 1850s. By 1854, a large French colony that the consul estimated at one-tenth that of San Francisco's population was solidly implanted in the city. With the advent of relative stability, many Frenchmen prospered. A dynamic French bourgeoisie appeared that invested heavily in real estate and ran successful businesses, such as wine importing, restaurants and cafés, dry goods stores, import stores, and banks. San Francisco's French contingent now had its own theater, hospital, church, newspapers, firefighters, and an active French consulate. The prestige of the French community kept growing, and the community celebrated Napoléon's birthday, Bastille Day, the Fourth of July, and Abraham Lincoln's birthday. (Author's collection.)

Three

PARIS OF THE PACIFIC

The end of the wild days of the Gold Rush became a turning point for French argonauts. Those who had come to California for the gold or for the thrill headed home. The others became dedicated San Francisco citizens who built a durable community that survived until World War II.

As San Francisco grew in wealth and beauty, French capital was widely used to help build the city, thanks to businessmen like F. L. A. Pioche, A. Borel, the Lazard brothers, and a score of smaller ones. The great French fashion stores like City of Paris, White House, and Roos Brothers, together with French architects, artists, and chefs, helped shape the city's early cosmopolitan image.

Because of its strong, early infusion of French "savoir-faire," San Francisco was dubbed the "Paris of the Pacific." It became French from the inside, with a large and active French colony centered on its hospital, its church, its newspapers, and multiple associations. This French community was itself as composite as San Francisco's general population, including southern Frenchmen conversant in Spanish who had arrived in the early days; residents of France's great ports of Bordeaux, Brest, Nantes, and even Toulon; and a large contingent of natives of Alsace and Lorraine.

The end of the 19th century, in turn, brought a great flow of immigrants from the provinces of Béarn and Aveyron, and from the Basque region. The failure of coal mines, the impact of industrialization on small rural communities, and compulsory military service, were all reasons for departure. A grapevine of friends and family members helped the new arrivals find employment in laundries, bakeries, at butchertown, and at *pensions*, small boarding houses that sprouted up all over San Francisco. They struggled at first to find their place within the established French colony. But each wave of French immigration eventually found its place within San Francisco's multicultural society.

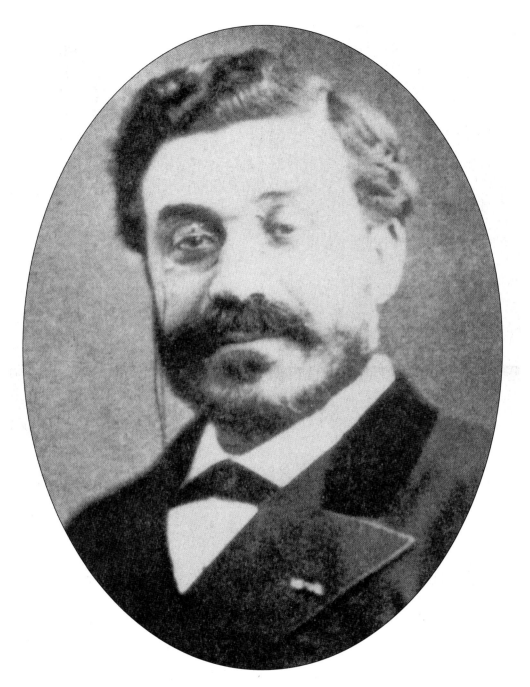

Louis Laurent Simonin. An engineer by vocation and a world traveler by avocation, Louis Laurent Simonin penned lively, informative articles during his travels from Washington to San Francisco in 1859 and again in 1868. He visited San Francisco at a time when the remnants of the Gold Rush still stood within the booming city. His travel accounts were published in *Le Tour du Monde*, a lavish French travel magazine. (Marie Paquette estate.)

FRENCH CAPITALIST FRANCOIS ALFRED PIOCHE. The investment firm operated by F. L. A. Pioche was one of the most important financial institutions in the West from the mid-1850s to the 1870s. Pioche financed and developed large-scale operations with capital raised in France, including a street railway that ran along Market Street from downtown's Battery Street to the vicinity of Mission Dolores. (San Francisco Public Library.)

P. HUERNE

Architecte et Ingénieur civil

Coin N.-O. des rues Kearny et Sacramento

(AU SECOND.)

Visible à son office de 2 heures à 8 heures.

PIONEER ARCHITECT PROSPER HUERNE. Many of F. L. A. Pioche's large-scale jobs were directed by French architect Prosper Huerne, who employed 500 men, 200 of them French. A native of Eure and Loire, Huerne reached San Francisco in June 1850 aboard the ship *Jacques Lafitte*. Among others, he designed the Bella Union gambling hall, and in 1853, he built the North Point docks using 150 French laborers. (Marie Paquette estate.)

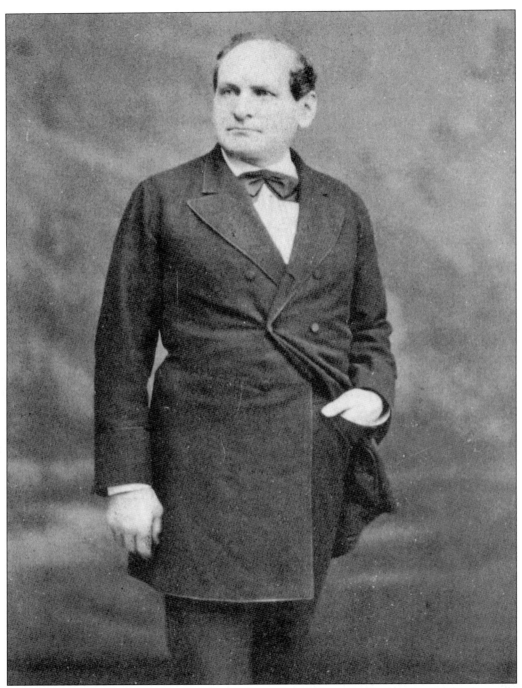

FRENCH BANKERS LAZARD FRERES. Simon Lazard was 16 years old when he left his home in Lorraine's Frauenberg, to rejoin his older brothers Alexandre and Lazard. They were bound for New Orleans where an uncle kept a dry goods store. The brothers caught gold fever, left for San Francisco in 1850, and opened an imported goods store. By the 1870s, they turned to banking. *Lazard Frères* ranks high today among international banks. (Simon Lazard.)

ANTOINE BOREL. This native of French Switzerland born in Neuchâtel in 1844, joined his elder brother Alfred in San Francisco in 1860 after studying industrial management in Switzerland. He became a brilliant investment banker and was a director for several California companies, including the Spring Valley Water Company, the Bank of California, the California Oregon Power Company, and the Los Angeles Railroad Company. In 1884, he organized a bankers' syndicate to purchase the California Street cable car line from Leland Stanford. Borel was the acknowledged leader of the Swiss community and its vice-consul from his arrival in 1860 until his return to Switzerland in 1913. After a 65-year absence, Borel Bank has returned to San Francisco at 433 California Street. (Right, Ronald Fick; below, author's collection.)

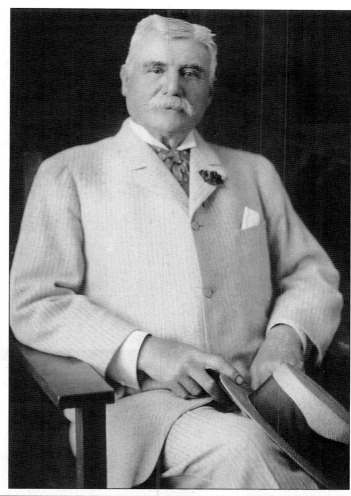

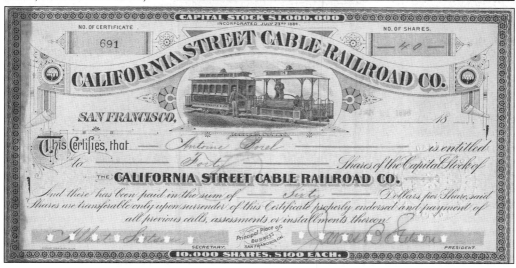

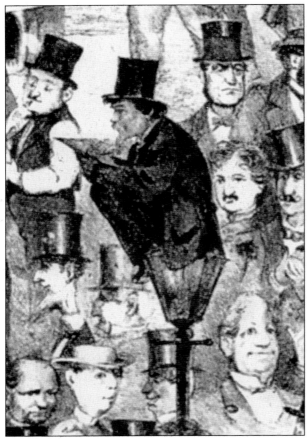

EDOUARD JUMP. Few Frenchmen endeared themselves more to San Franciscans than Edouard Jump. Born in Paris in 1831 and the son of a foreign language teacher, Jump was caught up in the Gold Rush excitement and headed for San Francisco aboard an English ship that landed in November 1851. After mining on the Tuolumne River, Jump returned to San Francisco, where he developed a satirical style with group scenes, earning him recognition as the "Prince of Cartoonists." (Bancroft Library.)

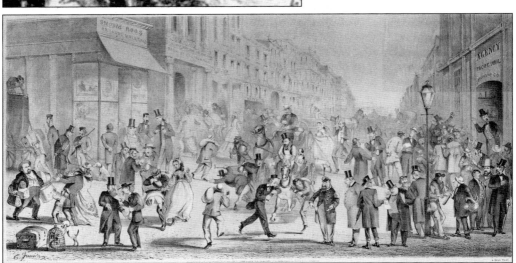

"STEAMER DAY IN SAN FRANCISCO." Edouard Jump depicted San Francisco events like this 1866 "Steamer Day" cartoon that shows the hustle and bustle of the 15th and 30th of each month when scheduled steamers arrived from or sailed back to the East Coast. On those days, all business deals had to close, and all letters and shipments had to be prepared. (Wells Fargo Museum.)

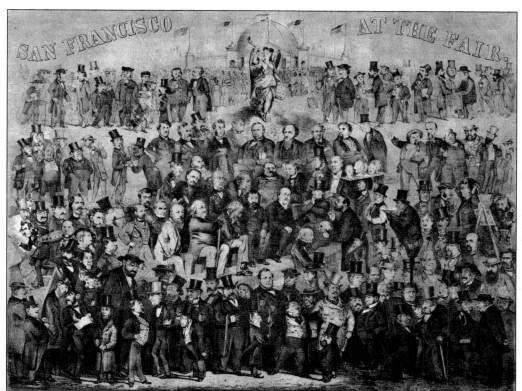

"SAN FRANCISCO AT THE FAIR." What made Edouard Jump's cartoons particularly exciting is that they were composed of identifiable portraits of prominent figures of the day, as with Emperor Norton in "Steamer Day." Other group scenes include this one, which depicts 158 prominent San Franciscans who attended the Mechanics Industrial Fair, including Frenchmen Etienne Derbec holding his newspaper; newsman Théodore Thièle; attorney Eugène Dupré; doctors Alexandre Huard and Emmanuel d'Oliveira; Gustave Drouillat; and Edouard Jump himself, sitting atop a lamppost on the right-hand side. (Bancroft Library.)

PRINCE OF CARTOONISTS. Edouard Jump was extremely skillful at reproducing faces and was said to sketch them on his thumbnails to consign them to memory. (Bob Chandler.)

THE CITY OF PARIS. Emile Verdier died during his third trip to San Francisco via the Isthmus of Panama. Then his brother Félix passed away in Paris in 1869. His 20-year-old son Gaston led the fourth trip and settled in San Francisco. He moved the store into the Occidental Hotel, San Francisco's most fashionable place, at Montgomery and Sutter Streets and had to leave almost immediately to join the French army in its fight against Prussia. Upon his return, Gaston transferred the store to its final site at Geary and Grant Streets on Union Square and changed its name from Ville de Paris to City of Paris. The card below was a complimentary gift to customers, who usually pasted the cards in scrapbooks. (Both, author's collection.)

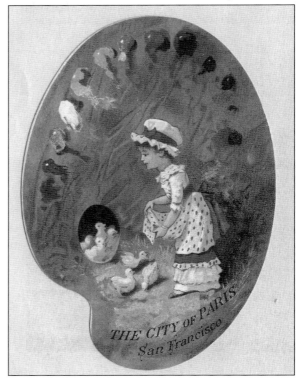

SAN FRANCISCO'S WHITE HOUSE.
A relative of Alexandre and Simon
Lazard, Phalsbourg-native Raphael
Weill reached San Francisco in 1855
after his ship was beached in San
Diego. This young Alsatian, who
had apprenticed at a novelty store in
Metz, soon found employment with
J. W. Davidson and Richard Lane, a
clothing store opened the previous
year. By 1858, the 20-year-old Weill
replaced Lane, who left for the placers.
The store then moved to Sacramento
Street and was renamed the White
House in reference to the famous
Parisian store. From silent partner in
1864, Weill soon became the owner
of the entire company, shown at
Post and Kearny Streets. In the days
of trade cards, the White House's
advertisement changed drastically
from Davidson's sweet Victorian
touch to Weill's dramatically artistic
style, as evidenced in the 1880s San
Francisco newspaper advertisement
below. (Both, author's collection.)

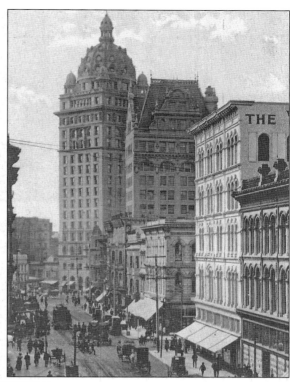

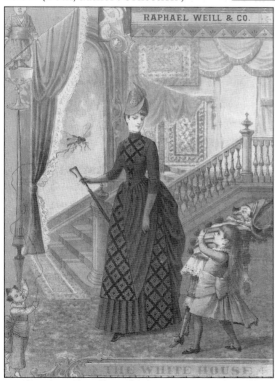

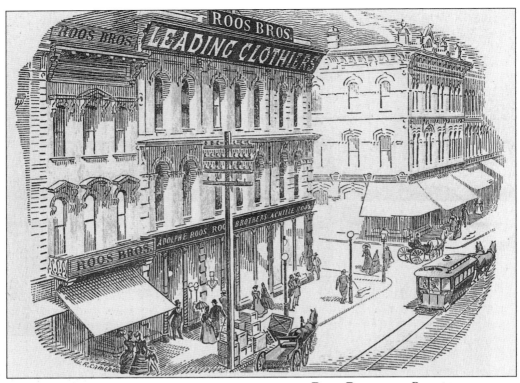

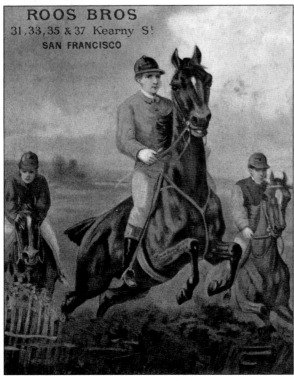

ROOS BROS
31, 33, 35 & 37 Kearny St.
SAN FRANCISCO

ROOS BROTHERS. Born in Wissenbourg, France, in 1837, Adolphe Roos came to San Francisco in the early 1860s and found employment working for a pioneer clothing merchant on Leidesdorff Street. In 1865, Roos bought out his employer and soon formed a partnership with his younger brother Achille, opening a small store at Post and Kearny Streets. (Author's collection.)

EARLY ADVERTISER. While Adolphe Roos handled the buying and financial operations, Achille Roos was in charge of selling and advertising. He became one of the outstanding sales promoters of his day by using local newspapers and trade cards, painted walls and fences, and guessing contests in their shop windows. Roos Brothers was one of the first retail stores to use billboards. (Author's collection.)

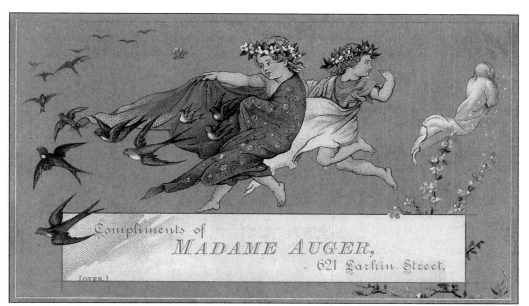

FRENCH BUSINESS WOMEN. In this delicate, early-20th-century trade card advertising Madame Auger's spring collection, the spirits of spring banish winter and welcome the new season with a flock of sparrows. (Author's collection, gift of Kathy Elliott.)

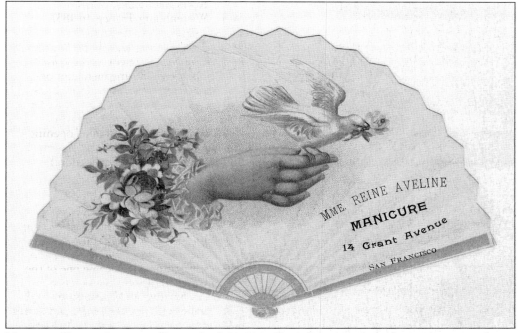

MADAME REINE AVELINE. Reine Aveline ran a French manicure and complexion parlor at the City of Paris on Grant Avenue. Hand-beautifier treatments cost 50¢ for ladies and $1 for gentlemen. (Author's collection.)

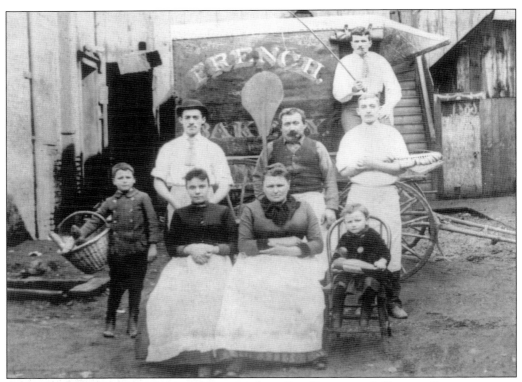

SAN FRANCISCO'S FRENCH SOURDOUGH BREAD. The bakery founded by Isidore Boudin and his family stands today as San Francisco's oldest French bakery. This photograph shows Isidore (center, back) holding a large, wooden baking paddle, and his wife Louise Erni, (center, front), whom he married at Notre Dame des Victoires in 1873. Their bakery was listed at 319 Dupont Street from 1852 to 1876. (Boudin Bakery.)

WAGNER'S BEER HALL. The son of a liquor merchant in Studweiller, Bas Rhin, Ferdinand E. Wagner migrated to Louisiana in 1836, married a native of Cannes in 1845, and opened a saloon. In 1852, he left for San Francisco, found work, and brought his family over the Isthmus of Panama. By 1868, he opened Wagner's Beer Hall at 308 Dupont Street. The building, renumbered as 1232 Grant Street, survived the 1906 earthquake and fire. It is now "the Saloon," one of the oldest in North Beach, and its bar still quenches San Franciscans' thirst. (Katherine Seineke.)

RONDEL PLACE. In 1869, French gem cutter E. Rondel, who had come to San Francisco with his wife Adèle aboard the *Moïse*, purchased a tract of land on Sixteenth and Mission Streets from A. F. L. Pioche. There he built 23 homes designed by Prosper Huerne on what became known as Rondel Place. His renters had the option to buy their homes over a number of years, a novel idea for the times. (Author's collection.)

THE FEUSIER OCTAGON HOUSE. Built in 1858 by a man who believed in the benefits of eight-sided houses, the Octagon House was purchased by French argonaut Louis Feusier. Feusier and his family lived in the house for 80 years. A friend of Leland Stanford and Mark Twain, Feusier was a commission merchant whose family also engaged in mining, salmon canning, and winemaking. A third floor and Mansard roof were added to the original house, which escaped the 1906 disaster. (Author's collection.)

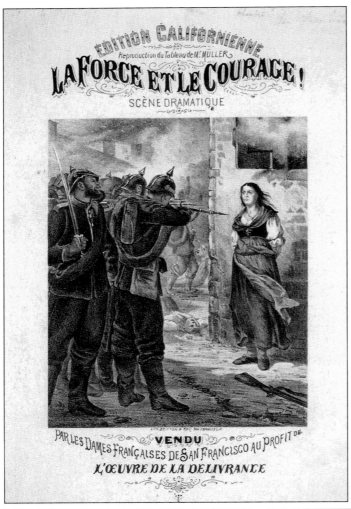

THE FRANCO-PRUSSIAN WAR. This bloody war, which took from France the provinces of Alsace and Lorraine, galvanized the large contingent of San Francisco Frenchmen. Gaston Verdier and Léon Weill served in the war, while those who remained in California organized, under Alexandre Weill's direction, the *Ligue Nationale de Délivrance* that gathered tens of thousands of dollars to help France with war expenditures, payment of the war debt, and to support to those who lost their homes to Germany. This patriotic song, engraved by Alsatian master engraver Jacques Joseph Rey, was sold as part of the fund-raising. The medals below were given in return for donations of jewels, cash, stocks, or whatever gifts the French citizens of California could provide toward the cause. (Left, Bancroft Library; below, Author's collection, gift of Bob Chandler.)

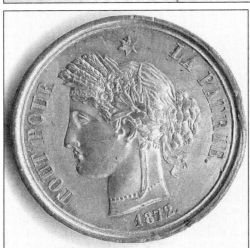

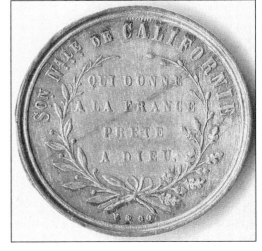

GASTON VERDIER AND LEON WEILL. Gaston Verdier had just settled in San Francisco and moved the City of Paris into the Occidental Hotel building when the Franco-Prussian War broke out. He left almost immediately to fight in the French army. He is shown here (seated, left) in the uniform of the Francs-Tireurs de la Loire with his friend Léon Weill standing behind him. More than 120 French-Californians lost their lives in that war. (Author's collection.)

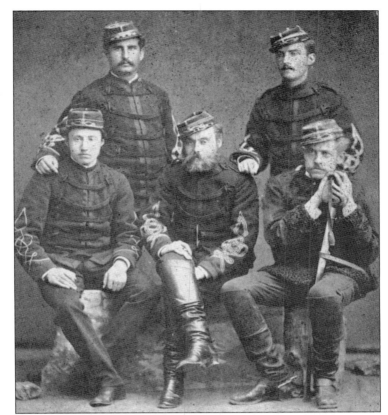

AFTER THE WAR. Born in San Francisco in 1867 to a Belgian father and Alsatian mother, Pauline Schoenmakers attended the California School of Design and studied under Amédée Joullin. In 1894, she received a Mid-Winter Fair bronze medal for her painting *After the War*, which depicts French weapons lying on a coffin covered with the American and French flags. Schoenmakers painted many fine portraits, still lifes, and landscapes between 1889 and 1899. (Stephen H. Meyer.)

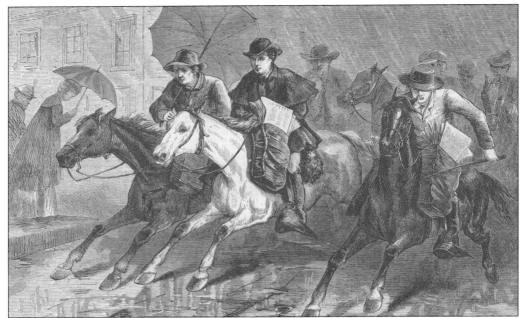

PAUL FRENZENY'S SAN FRANCISCO SKETCHES. A veteran of the French wars in Algeria and Mexico, Frenzeny studied in New York under John N. Hyde and sketched New York's humble folks for *Harper's Weekly*. The Harper brothers hired him to illustrate the American frontier with his talented compatriot Jules Tavernier. After they reached California, Frenzeny went on working for *Harper's Weekly*, producing numerous illustrations of the West, including this April 1877 glimpse of San Francisco newsboys riding spirited mustangs. Frenzeny, who was fascinated with other cultures, left an unparalleled visual chronicle of San Francisco's Chinese community, including this January 1882 engraving of a procession of Chinese musicians with gongs and hired mourners in San Francisco's Lone Mountain cemetery. (Both, author's collection.)

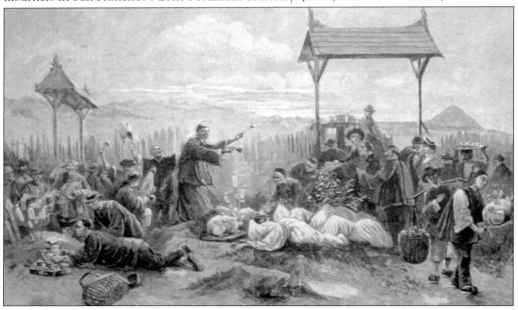

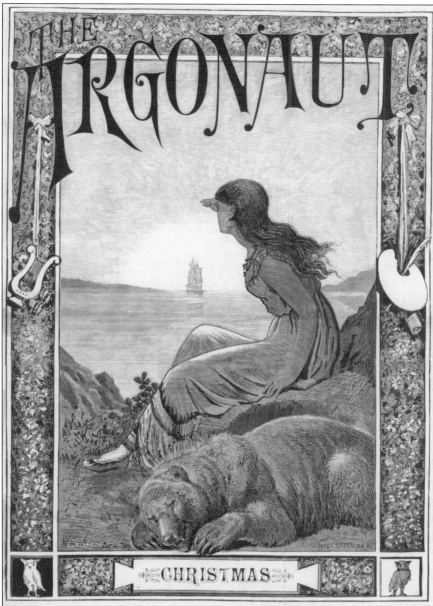

JULES TAVERNIER. Paris-born Jules Tavernier trained with Beaux-Arts master Félix Barrias and at Barbizon, exhibiting his work at the Paris Salon in the 1860s before leaving France for London and then sailing to New York. In 1873, *Harper's Weekly* hired him along with Paul Frenzeny for a highly coveted coast-to-coast sketching tour of the frontier. Once in California, Tavernier reverted to painting, first in the wilds of Monterey, where his studio became the embryo of an artist colony that continues today. Back in San Francisco in the early 1880s, the "Bohemian of Bohemians" painted beautiful sceneries, rarely sketching again except for this 1880 engraving of the great seal of California, used as the *Argonaut Magazine*'s Christmas cover several years in a row. Tavernier's art studio, an old courthouse-turned-studio at 728 Montgomery Street, remained an artist's den for decades after his departure for Hawaii in 1884. (Author's collection.)

AMEDEE JOULLIN'S *FRENCH POULTRY MARKET*. Born in San Francisco of French parents, Amédée Joullin chose painting over his father's printer's trade, first studying at the California School of Design, then under Jules Tavernier for two years. He studied art for two years at the Académie Julian and at the Ecole des Beaux-Arts in Paris. Upon his return to France, he married a French woman at Notre Dame des Victoires , where his parents had wed in 1861, and became a popular instructor at the California School of Design for 10 years. His *French Poultry Market* depicts a dilapidated shop on Merchant Street, opposite his studio, on what was known as "studio row." Having acquired extensive interest in Native American subjects from his mentor Tavernier, Joullin earned a great reputation for his paintings of Pueblo Indian life in New Mexico. (Private collection.)

ALBERT PISSIS. Born in 1852 of French parents in Guaymas, Mexico, Albert Pissis moved to San Francisco at age six. He was apprenticed with Swiss architect William Mooser before spending five years at the Ecole des Beaux-Arts in Paris. He returned to work again for Mooser in 1877, then set up shop on his own in San Francisco in 1881. Many members of San Francisco's French community like Paul Fleury and the Roulliers commissioned him to design private homes, but Pissis is best known for the large, commercial buildings he designed: the Hibernia Bank building, 1889; the Emporium building, 1896; and the Flood building, 1904. After the 1906 disaster, Pissis' Beaux-Arts-inspired "commercial classicism" became a hallmark of the city's reconstruction with two dozen new buildings, including the White House in 1908 and the Anglo London and Paris National Bank building in 1910. (Montana State University, Bozeman.)

SAN FRANCISCO'S BELOVED POODLE DOG. As it moved from Grant and Bush Streets in 1868 to a spectacular, six-story, pressed-brick building designed by William Mooser at Eddy and Mason Streets in 1898, the Poodle Dog was transformed from a Gold Rush shack to the extreme of Victorian elegance. In the tradition of the "Gay Nineties," this crème-de-la-crème hotel-restaurant, which took two years to design, consisted of a public dining room on the first floor for respectable folks, a pantry on the second floor, and two large banquet rooms with their own kitchen on the sixth floor. A private elevator in the rear whisked couples into suites on the third, fourth, and fifth floors, which included a parlor, a bedroom, and a bathroom, all with locks on the doors. Privy to many secrets, the elevator operator was said to wear a diamond pin and have retired a rich man. (Both, author's collection.)

THE POODLE'S MODERN-DAY MAGNIFICENCE. It took two years "of indefatigable labor," to design the new Poodle Dog, according to its owners, and its renown came largely from the excellence of its cuisine and 18-chef staff. Its large, central range was unique in the United States since it had ovens on both sides. It served as a divider for the zone where "table d'hôte" meals were prepared and where "à la carte" meals were made to order. The wine cellars were particularly well stocked with wines from the world over. Separate wings held Clarets, Burgundies, Rhine wines, Champagnes, and more with separate temperatures for each. A bottler is shown here bottling from casks the restaurant's regular table claret, a fine, aged "Chateau Chevalier" Napa Valley wine. The cellars held 10,000 bottles. (Both, author's collection.)

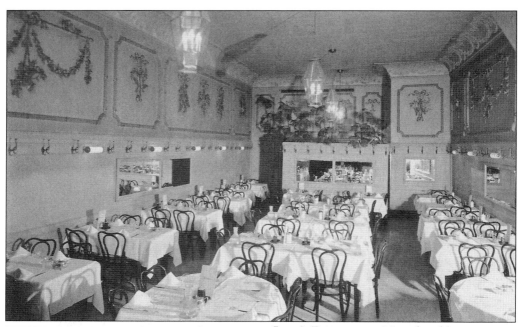

Jack's Rotisserie

615 Sacramento Street

Phone Kearny 5990. San Francisco, Cal.

JACK'S ROTISSERIE. Now the oldest French restaurant in San Francisco, Jack's Rotisserie has always resisted trends. It has been owned by the same family since 1903 and has had the same address at 615 Sacramento Street since 1864 when it was founded by Frenchmen Frank Lacoste and Jack Mounique. As Herb Caen put it, the restaurant has all this time had "the same menu, the same waiters (wellll, almost), the same tablecloths." Jack's is also the spot where customers such as John Barrymore, Ernest Hemingway, Alfred Hitchcock, power brokers, and tycoons were always able to meet and eat without making the headlines. The classic décor of its dining room has 14-foot ceilings and sculpted relief on the walls of jackrabbits that once roamed nearby and provided convenient fare. Bought by John Konstin in 1996, the historical landmark has been retrofitted and spruced up. (Both, author's collection.)

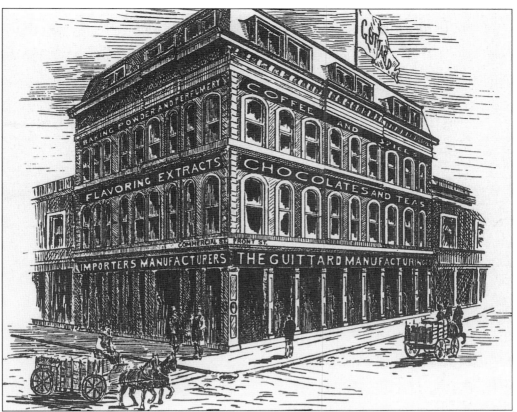

ETIENNE GUITTARD. Etienne Guittard reached San Francisco in the 1860s and, like many, tried his hand at mining without much luck. Shopkeepers in San Francisco remembered the chocolate he had sold them upon reaching their town and encouraged him to pursue his trade—he had trained with a chocolatier uncle in Paris. Etienne returned to Paris, saved and scrimped, and bought equipment that he brought to San Francisco, opening Guittard Chocolate on Commercial Street in 1868 at age 30. He later moved to this four-story building at the corner of Front and Commercial Streets that was specifically fitted for the company, including all the latest and most improved machinery. Guittard imported green coffees, raw cocoas, spices, vanilla, oils, and teas from all over the world. (Above, gift of Ernest Peninou; right, author's collection.)

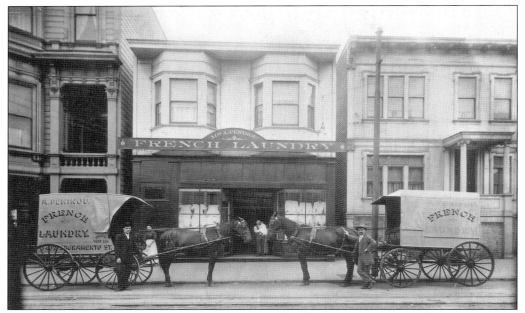

PENINOU'S FRENCH LAUNDRY. A native of a small village near Pau in southwestern France, André Peninou came to San Francisco in 1896, sponsored by his uncle J. P. Trouillet, who owned a laundry on Polk Street. The young Béarnais knew how to handle horses and was put in charge of the delivery wagon. He also knew how to save and soon was able to open his own successful laundry. When André died, his widow—who was born on Bastille Day—took over the running of the laundry, which employed dozens of workers, most from Béarn. The laundry served for many years as a training ground for in-coming Béarnais emigrants. André's son Ernest was a dedicated California historian and wine enthusiast. (Both, author's collection, gift of Ernest Peninou.)

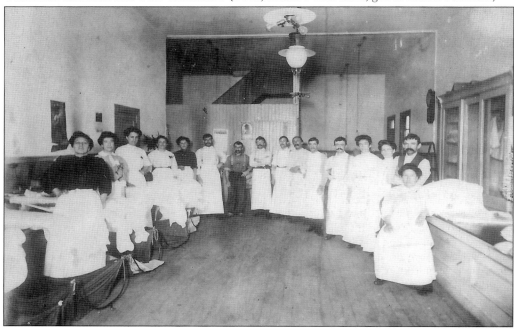

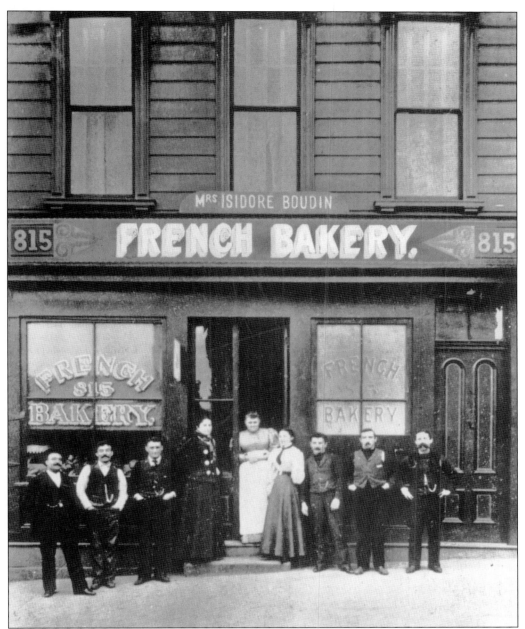

SAN FRANCISCO'S "LATIN QUARTER." In the 1880s, the intersection of Grant Street and Broadway became known as the "Latin Quarter," so nicknamed because its population was in major part composed of Frenchmen and Italians. The area was filled with French hotels, restaurants, cafés, tables d'hôtes, fashion stores, tailors and seamstresses, hairdressers, garages and mechanics, construction companies, and laundries that remained a synonym of quality in the entire city for decades, as well as French bakeries. After Isidore Boudin's death in the 1890s, Louise Boudin carried on the bakery business with the help of her two sons and two daughters, just as Madame Peninou and many other French widows did to survive. She moved the store to 815 Broadway in the Latin Quarter just below today's Broadway tunnel. (Boudin Bakery.)

FRENCH HOTELS AND PENSIONS. Early-20th-century immigrants from the southwest of France did not seek adventure like earlier French argonauts but rather sought employment and steady wages. Besides laundries and bakeries, *pensions* (boarding houses) became a convenient source of network employment for these newcomers, like the Hotel d'Oloron on Columbus Avenue, shown here. Used to thrift, a great number of these small hotel operators were able to own their establishment outright after just a few years. (Author's collection.)

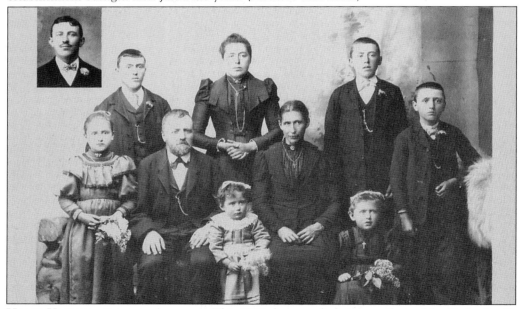

HOTEL KEEPERS FROM THE AVEYRON. This 1898 photograph shows members of the Cerles family in the industrial town of Decazeville, France. Pictured from left to right are (first row) Lucie, Benjamin, Laure, Séraphie, and Benjamine; (second row) Firmin, Marie, Théophile, and Alfred; (inset) Alphonse. Alphonse left for San Francisco in 1896. Of these 10 natives of the region of Aveyron, all except for Marie and Firmin left their ancestral home to settle in San Francisco. (Robert E. David.)

ALPHONSE AND CLEMENCE CERLES. Alphonse married Clémence Anric, who was also of French heritage. Their wedding was performed in San Francisco in January 1913 and again in Anglars, France, one week later. One of Alphonse's younger sisters, Benjamine, also married in San Francisco and, with her husband, Henri Achille Madrières, a native of Aveyron, operated small downtown hotels where they lived for a while before buying a flat on Franklin Street. (Alrene Grialou Flynn.)

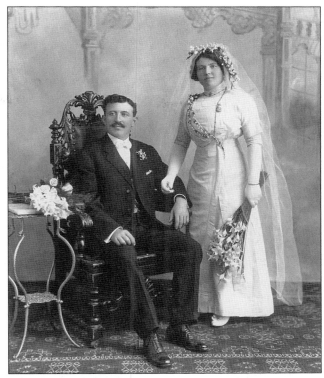

FRENCH ORIGINS OF BEST WESTERN MOTELS. In the 1940s, Camille Grialou and his son René built the Flamingo City Center Motel on Seventh Street. They used a teletype machine to book advanced reservation between their motel and one in Los Angeles for customers traveling between the two cities. This strengthened the bonds between the two motels. New ones were added to this network, eventually taking the name Best Western in 1948. This photographs shows three generations of Grialous. From left to right are Raymond, René, and Camille. (Alrene Grialou Flynn.)

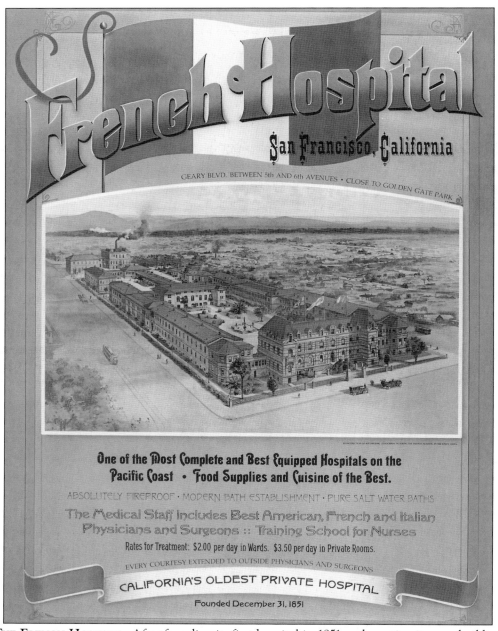

THE FRENCH HOSPITAL. After founding its first hospital in 1851 and erecting its own building in the 1870s (see p. 38), the French Mutual Benevolent Society acquired a large piece of land at Point Lobos Avenue, today's Geary Boulevard, between Fifth and Sixth Avenues. There the society built a modern facility in 1895 that quickly became one of the Pacific Coast's leading hospitals. It had separate buildings for administration, maternity, and an elderly care facility. It also housed a nurses' wing, an isolation ward, operating rooms, an amphitheater, and modern patients' rooms with baths. Membership in the hospital was intended for people of French descent and soared to 10,000 members by 1950. This poster was created in 1925 for the building's 30th anniversary. (French Mutual Benevolent Society.)

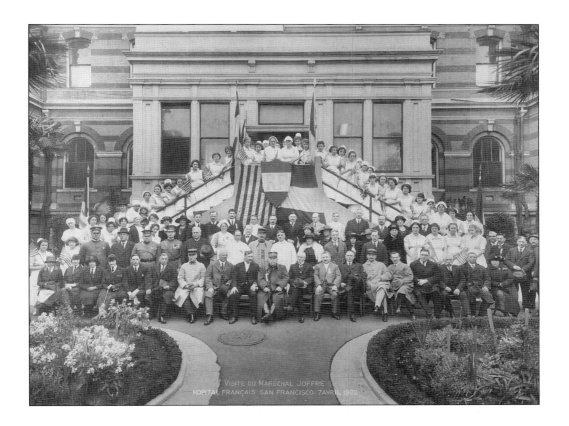

NURSING SCHOOL. The French Hospital was such a reputed establishment that it was often visited by luminaries, in this instance Marshal Joffre in 1922. The photograph below highlights the human side of this great hospital, which had a nurse training school within its facilities. (Moulin Studio, author's collection, San Francisco Public Library.)

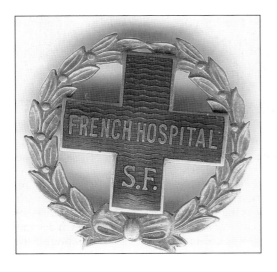

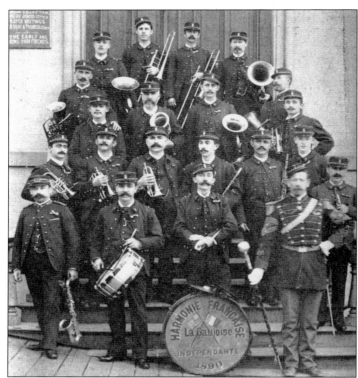

LA GAULOISE. Newcomers who had moved from a rural area to an urban setting often felt nostalgia for their native lands. They enjoyed getting together to remember the old country. The Aveyronnais created a club and band in 1889 that allowed them to enjoy familiar tunes from back home. Two years later, it transformed into a Mutual Aid Society, "La Gauloise," which provided help to ill or injured members, and funds for burials. (Author's collection.)

PROVINCIAL COSTUMES. Regional French costumes were worn at many celebrations as a reminder of the residents' hometowns. This group is wearing the delicate, lace coifs and aprons of Brittany. (Author's collection.)

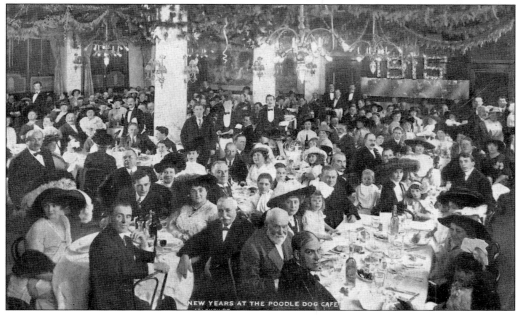

Ordre des Danses.

18. Two-Step

19. Schottische

20. Waltz

21. Polka

22. Extra

23. Extra

24. Extra

BANQUETS AND BALLS. Elaborate banquets and balls were a way of life for San Francisco's French colony. This particular Ligue Henri IV ball, which took place at the Native Sons' Hall on December 3, 1904, had no less than 24 dances scheduled in advance as this carnet de bal (above) shows. Supper was served midway through the program, with a selection of Georges Bizet's *Carmen* and a few popular airs being played during the meal. All holidays were celebrated in grand style, with photographs taken before good wine and cheer marred the revelers' composure, as in this 1915 New Year's banquet at the Poodle Dog restaurant (below). (Both, author's collection.)

NEW YEARS AT THE POODLE DOG CAFE

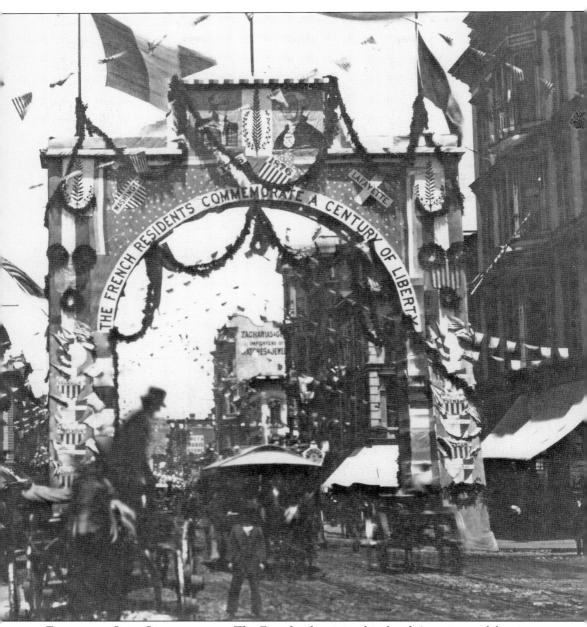

FOURTH OF JULY CELEBRATIONS. The French often joined in local American celebrations, as in the 1876 centennial when they erected a triumphal arch to George Washington and Marquis de Lafayette at Kearny and Post Streets, at the cost of $1,000. This occurred so soon after the Franco-Prussian War that there was much apprehension when a German band paraded in the vicinity. To everyone's relief, the German band marched through striking up "La Marseillaise," the French national anthem. (Author's collection.)

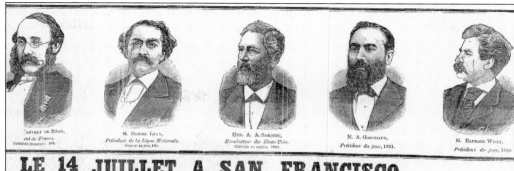

LE 14 JUILLET A SAN FRANCISCO

BASTILLE DAY CELEBRATIONS. The storming of the Bastille did not have the same significance to all members of the French community, who remained quite divided politically. Even the French consul at times opposed these Republican celebrations. Still, under the impulse of Raphael Weill, the first Bastille Day celebration occurred on July 14, 1880, at Woodwards Garden. The *Courrier de San Francisco* (above) published portraits of the French colony's dignitaries involved in the 1881 celebrations, among them Weill and writer Daniel Levy, whose 1885 book *Les Français en Californie* remains a remarkable source of information. Although not well attended the first years, these celebrations peaked in 1889 for the bicentennial of the French revolution. The parade was sketched by French Californian artist Jules Eugène Pagès for the *San Francisco Examiner* (below). (Above, Robert Chandler; below, San Francisco Public Library.)

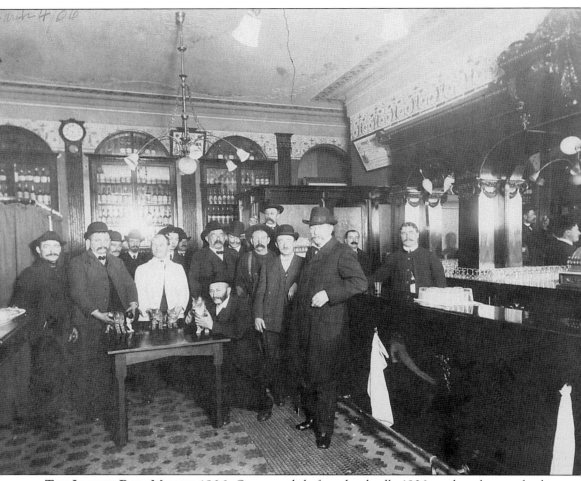

THE LLANES BAR, MARCH 1906. One month before the deadly 1906 earthquake struck, the regulars at Llanes Bar located at Leidsdorf and Commercial Streets were celebrating a fresh litter of kittens from the bar's cat, whose job it was to keep the premises rat-free. In the early morning of April 18, 1906, barkeeper François David (right), a native of Lurbe in the Béarn, was cleaning up from the night before when the quake hit, shaking the building until it collapsed. David managed to escape, ran to his apartment, and grabbed a few of his belongings before the ensuing fire engulfed his neighborhood. He moved to Marin County temporarily after that ordeal, working as a farmhand and a cowboy, before marrying Augustine Bordenave, a San Francisco native of French heritage. He later became a motorman for the Market Street Railway. (Robert E. David.)

Four

HORROR AND
RECONSTRUCTION

In the early morning of April 18, 1906, San Francisco was struck by one of the largest earthquakes ever recorded in North America. The ensuing conflagration was more destructive than the Great Fire of London in 1666 or the Great Chicago Fire of 1871. The French community was not spared; large and small businesses, private homes, and institutions were destroyed. All of the French consulate's documents and archives, and the entirety of the 22,000 books in the Ligue Nationale Française library. Collections of the 30 or so different French newspapers published in San Francisco since 1852 disappeared as well, not to mention precious artwork by French artists. Notre-Dame's fathers however managed to preserve their early records, and Louise Boudin ran out of her burning bakery with a bucket full of her precious mother-dough.

Like San Franciscans at large, many of the estimated 8,000 French nationals left San Francisco for its outskirts or for the East Bay, Oakland, and Berkeley. Many also rolled up their sleeves and went to work: San Francisco's reconstruction was a subject of wonder for the rest of the world, including France. By 1912, the city's great French fashion stores were back, more beautiful than ever; small businesses migrated to new parts of town; by 1924, the library of the Ligue Nationale Française moved to the eighth floor of the French-American Bank and had already gathered more than 20,000 books—although many irreplaceable treasures were gone forever.

The Panama Pacific International Exposition, created to commemorate the 400th anniversary of Balboa's discovery of the Pacific Ocean and the completion of the Panama Canal in 1914, actually became a grand celebration of San Francisco's quick reconstruction. Although embroiled in a war with Germany, France shone at the exposition with an art pavilion that contained the exposition's largest art exhibit.

The replica of Hotel de Salm for the French art pavilion seduced sugar tycoon Adolph D. Spreckels and his audacious wife. Alma Spreckels's vision of a grand museum at San Francisco's Land's End produced the remarkable Palace of the Legion of Honor, which further anchored the city's French community by providing a gathering place filled with familiar architecture and familiar art from their native home, among them Rodin's timeless statues.

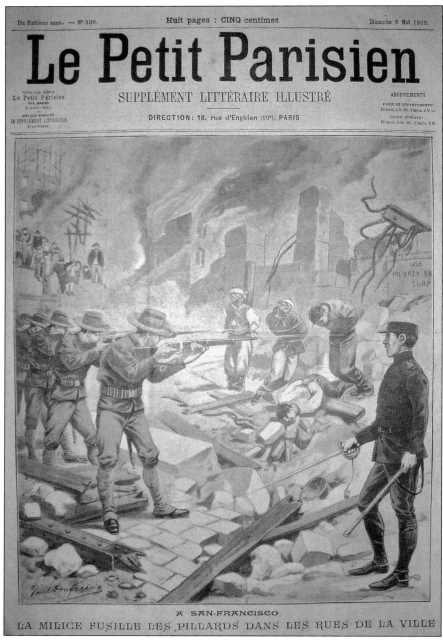

Dix Huitième année — N° 900. Huit pages : CINQ centimes Dimanche 6 Mai 1906.

Le Petit Parisien

SUPPLÉMENT LITTÉRAIRE ILLUSTRÉ

TOUS LES JOURS
Le Petit Parisien
(SIX pages)
5 centimes

CHAQUE SEMAINE
LE SUPPLÉMENT LITTÉRAIRE
5 centimes

DIRECTION: 18, rue d'Enghien (10e). PARIS

ABONNEMENTS

PARIS ET DÉPARTEMENTS
12 mois, 4 fr. 50. 6 mois, 2 fr. 25

UNION POSTALE
12 mois, 5 fr. 50. 6 mois, 3 fr.

A SAN-FRANCISCO
LA MILICE FUSILLE LES PILLARDS DANS LES RUES DE LA VILLE

THE NEWS IN FRANCE. This sensational Parisian newspaper was quick to report the most dramatic moment of the earthquake's aftermath: the execution of suspected looters. This became a chilling reality for store owners Adrien Esmiol and Gustave Allibert, who searched their damaged building and removed bolts of fabrics that they buried at the marina's beach. When they returned a few days later, thousands of refugees had pitched camp on the beach. After searching for hours, the partners found their trunks and were pressed to sell their merchandise on the spot. Vigilantes accused them of looting. Esmiol and Allibert barely escaped execution when fellow Frenchmen recognized them and confirmed their identities to the vigilantes. (Author's collection.)

SAN FRANCISCO IS NO MORE. Twenty-seven-year-old San Franciscan Antoine Borel Jr. lost his bank building to dynamite as the fire spread. He reported: "Market Street near the ferries sank many feet. Van Ness near Vallejo sank down over four feet. The whole city is destroyed—from the Ferry Building to the Presidio, and from the Beach to the Potrero—every street went up in flames." (Ronald Fick.)

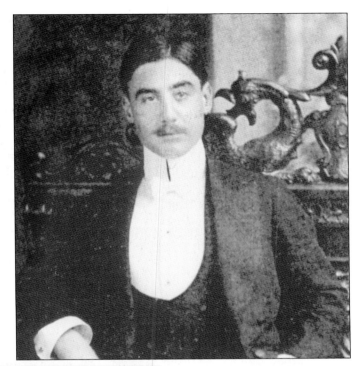

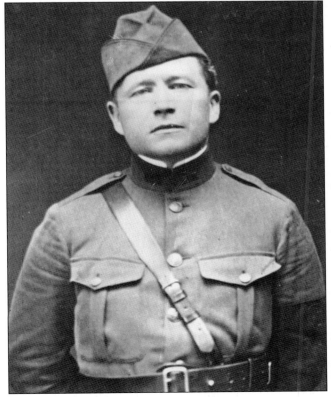

TOSSED LIKE A FISH IN A FRYING PAN. In a remarkable account, Paris-born Jean-Marie Hopper related his ordeal at being tossed in his bed and went on to describe the frightful tremor: "It pounced upon the earth as some sidereal bulldog, with a rattle of hungry eagerness. The earth was a rat, shaken in the grinding teeth, shaken, shaken, shaken with periods of slight weariness followed by new bursts of vicious rage." (San Francisco Public Library.)

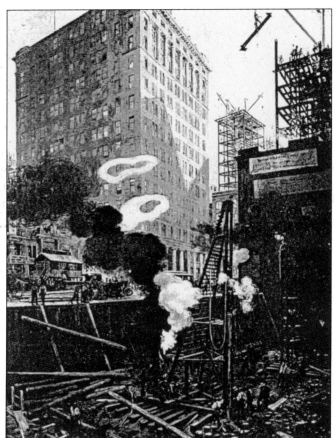

THE RECONSTRUCTION OF SAN FRANCISCO. San Francisco–native artist Jules Pagès was the only California artist of French descent to become a permanent resident of France after studying at the Ecole des Beaux-Arts. He remained a Californian at heart and exhibited this striking oil of his native city's rebirth at the 1909 Salon de Paris: *Réédification de San Francisco, un an après la catastrophe.* (Author's collection.)

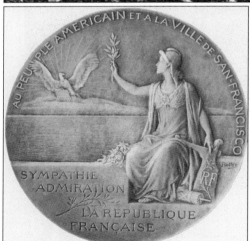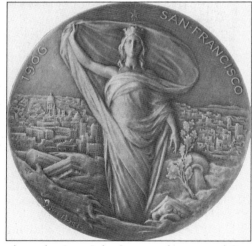

SYMPATHIE ET ADMIRATION. In 1909, French ambassador Jean Jules Jusserand presented San Francisco's officials a medallion of pure gold at the Orpheum Theater. The medallion, crafted by artist Louis Bottée and specially minted in France, celebrated the resurrection of the city, shown rising from its ashes, throwing off her shroud on one side, with France offering a branch of laurel to America on the reverse. The medallion is on exhibit at city hall today. (Author's collection.)

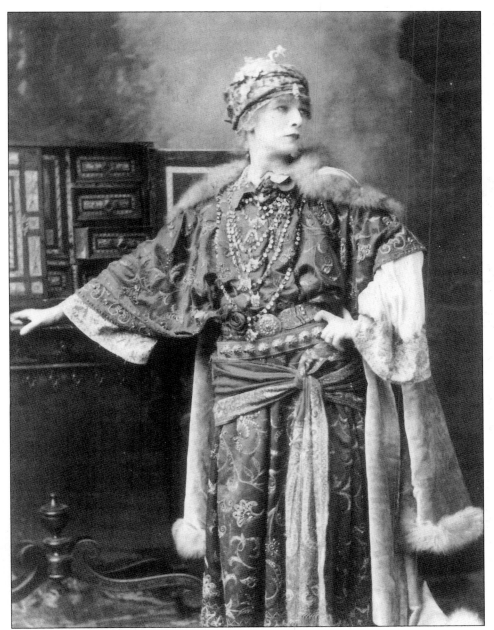

THE DIVINE SARAH'S FUND-RAISERS. Famous French actress Sarah Bernhardt first performed in San Francisco in 1887, taking the city by storm. This triumph was followed by another in 1891: "My heart beats with emotion at leaving this adorable and hospitable city. I cry au revoir to all and thanks to each," Bernhardt said in farewell when she returned to France with 81 cases of California champagne in her luggage. When she learned of the devastating San Francisco earthquake and fire, Bernhardt performed a benefit for the city's homeless in Chicago, raising close to $17,000. She then rushed to San Francisco where all theaters had been destroyed for an inspiring show at Ye Old Liberty Playhouse in Oakland on May 27, 1906, donating a percentage of the proceeds to relief funds. (California State Library.)

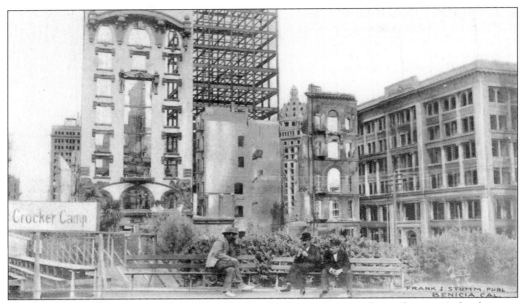

CITY OF PARIS DESTROYED. By 1890, Felix Verdier's son Gaston chose the store's final site at Geary and Grant Streets on Union Square, and the store's name was changed to City of Paris. Only two years after Gaston turned the management of the store over to his son Paul, the building was completely destroyed by the earthquake and fire. (Author's collection.)

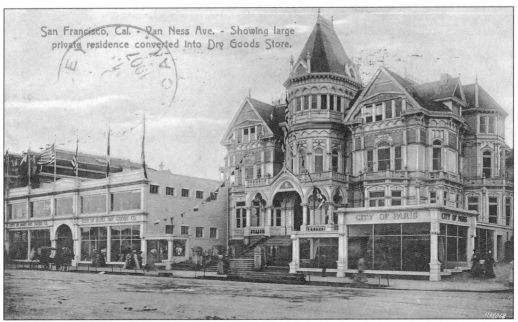

CITY OF PARIS RELOCATES. Paul Verdier used his friend Walter S. Hobart's mansion on Van Ness Avenue and Washington Street to temporarily house the fashionable store. According to the store's literature, the store did not lack in character, as linens were sold in the dining room, silks and laces in the drawing room, books in the library, and fluffy French lingerie in the bedrooms. (Author's collection.)

A NEW "CITY OF PARIS." By 1907, the City of Paris was rebuilt at its final location on Geary at Stockton. The new seign by Beaux-Arts-trained architects Brown and Bakewell and French architect, Louis Bourgeois, included a beautiful rotunda with an open view of all the floors. This circular interior was topped by a stained-glass dome depicting the arms of Paris (see page 2.) (Author's collection.)

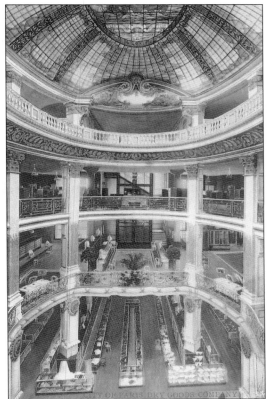

THE CHRISTMAS TREE STORE. After it was rebuilt in 1909, a visit to the City of Paris became a never-to-be-missed Christmas tradition in San Francisco every year. A giant tree soared in the rotunda all the way up to the fourth floor, revolving and glistening with a thousand lights and a hundred gifts. The tree was so gigantic that tricycles, skis, ice skates and sleds were used as decoration. (Author's collection.)

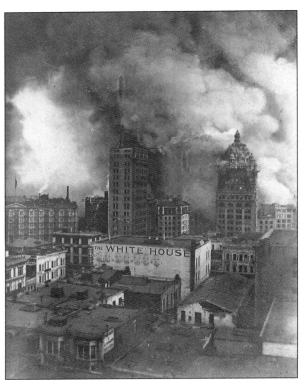

MERCHANT PRINCE RAPHAEL WEILL. After the 1906 earthquake and fire destroyed the White House, owner Raphael Weill ordered a shipment of 5,000 dresses and suits that he distributed to San Francisco's women refugees so unostentatiously that only relief workers knew of it. A few years later, when many of his 1,500 employees were drafted to serve in World War I, Weill put half of their salary into their book accounts for an entire year during their absence. This tireless philanthropist's influence and popularity were considerable. He was also a popular Bohemian Club member who lodged at the club's headquarters and was known for the exquisite Sunday morning breakfasts he cooked there. Chefs from Maison Dorée, St. Germain, Chantilly, and Jack's Rotisserie, whom Weill had helped bring to San Francisco, gave his name to dishes. (Left, Robert Chandler; below, Author's collection.)

M. RAPHAEL WEILL

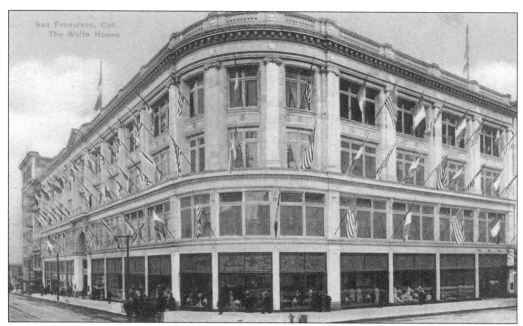

THE WHITE HOUSE GRAND REOPENING. On March 13, 1909, the White House was resurrected at the corner of Sutter and Grant Streets with a beautiful, stone building designed by French Californian architect Albert Pissis. The four-story structure had a massive steel frame anchoring the corner of the two streets. It is shown on opening day with French and American flags along its facade. (Author's collection.)

RAPHAEL WEILL SCHOOL. Weill was a revered philanthropist, honored by both the French colony and the city's fathers. In 1927, his name was given to a school built in San Francisco's western addition. It is now known as Rosa Parks Elementary School, but it shares its campus with a children's center that has retained Raphael Weill's name. (Author's collection.)

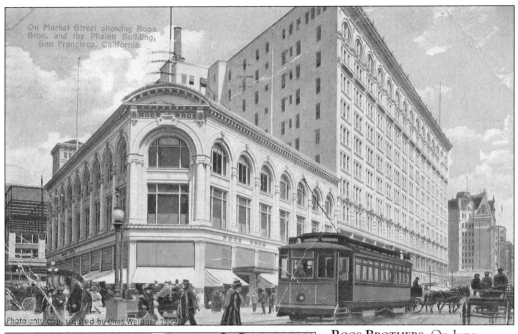

ROOS BROTHERS. On June 15, 1906, Roos Brothers was opened for business again at Fillmore and O'Farrell Streets. By 1908, a new store designed in terra-cotta by Albert Pissis was opened at Market and Stockton Streets. By 1935, Roos Brothers operated nine stores: two each in San Francisco and Berkeley, and one in Oakland, Palo Alto, San Jose, Fresno, Sacramento, and Hollywood. (Both, author's collection.)

THE ROOS RESIDENCE. One of the beautiful homes erected in San Francisco for wealthy Frenchmen is the Roos' family residence, built in 1909 on Jackson Street by Morris Meyerfield for his daughter's impending marriage to Adolphe and Ernestine's son Léon. It was designed by famed architect Bernard Maybeck and decorated inside in flamboyant Gothic style. (Above, author's collection; right, Bancroft Library.)

"Barcelonnette" Adrien Esmiol. In 1898, at age 17, Adrien Esmiol left Digne for Mexico City with a friend, spent four years working in a dry goods store, and then headed for San Francisco in 1902. There he worked for a men's clothing store and soon founded La Samaritaine in North Beach with his friend Gustave Alibert. (Claude Esmiol Martini.)

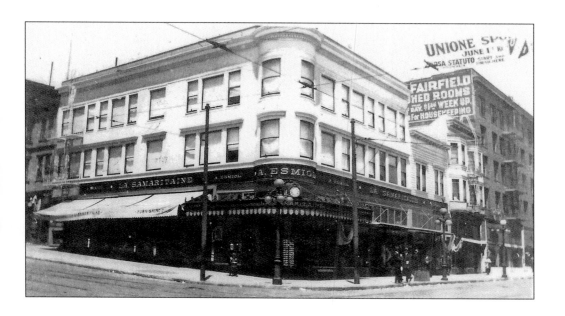

LA SAMARITAINE. The modest 10-foot-by-15-foot La Samaritaine store was destroyed in December 1906 by 90-mile-per-hour winds that collapsed the building over owner Adrien Esmiol and two workers. The workers died, and Esmiol was in serious condition. Despite the horrendous experience, Esmiol and his friend Gustave Allibert rebuilt La Samaritaine in 1907. When Allibert retired in 1914, Esmiol added several floors, turning his store into one of the most modern buildings in town. When Esmiol retired in 1935, he and his wife, Juliette, shared their time between their villa "la Californie" in Digne and San Francisco where he loved driving this brand new automobile. (Both, Claude Esmiol Martini.)

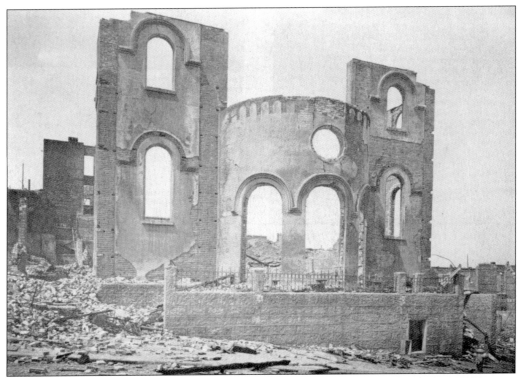

NOTRE DAME DES VICTOIRES DESTROYED. On April 18, 1906, the French church's roof collapsed. As the flames raced up Bush Street, Fathers Joseph Guibert and Henri Thiéry buried the sacred vessels in the courtyard garden along with the registry of marriages and christenings. They were found intact several days later, although the church was not spared. Notre Dame was one of the rare parishes that preserved its pre-1906 records. (Fr. E. Siffert.)

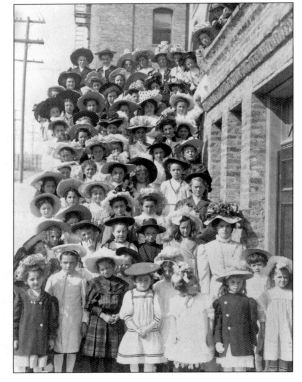

GIRLS ATTENDING MASS, 1908. Many French San Franciscans moved to the East Bay. Some felt Notre Dame des Victoires should be moved, but the general attachment to the building prevailed. From the ruins, the crypt was rebuilt and opened for Mass in the fall of 1907, as this photograph shows. Father Thiéry then undertook to raise the funds needed to rebuild the church proper. (California Historical Society.)

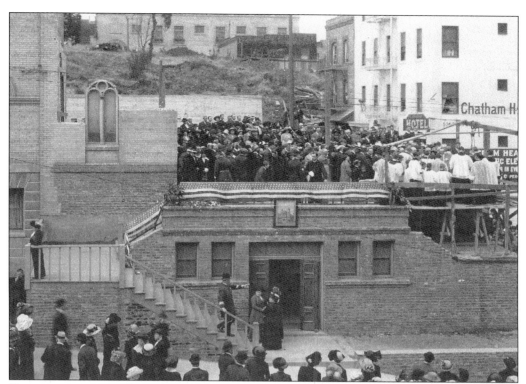

DEDICATION OF THE CORNERSTONE. In May 1913, the cornerstone of the new church was blessed by San Francisco Archbishop Edward Hanna. Plans were proposed to repeat the interior of the old Notre Dame des Victoires , but the facade was redone on the model of the basilica Notre-Dame de Fourvière built in Lyon in 1894. (Fr. E. Siffert.)

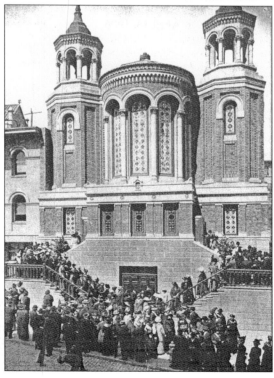

THE NEW NOTRE DAME DES VICTOIRES. On September 12, 1915, Notre Dame des Victoires 's new building was rededicated with a solemn Mass for the souls of the soldiers killed in the bloody war in France. The church was draped in rich decorations thanks to Raphael Weill who, although not a Catholic, wished to participate in the patriotic event. A plaque inside the church recalls the 120 young French Californians who died in World War I. (Fr. E. Siffert.)

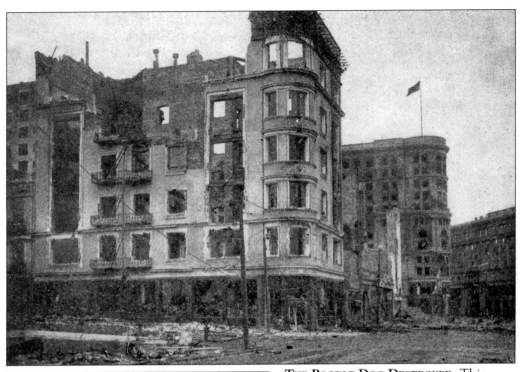

THE POODLE DOG DESTROYED. This photograph shows all that was left of the James Flood building and the Poodle Dog restaurant, both victims of the San Francisco disaster. The lavishly-built Poodle Dog of 1898 occupied the entire building in the foreground. The ruins if the Flood Building and Emporium department store are to the rear. (Author's collection.)

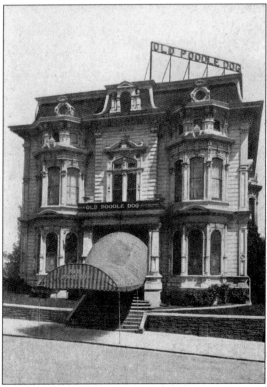

THE POODLE DOG RELOCATES. In June 1906, the Poodle Dog moved to a residential building on Eddy Street. It never quite recovered from the loss of its spectacular 1898 building, yet it remained a landmark eatery. Socialite Amelia Ransome Neville recalled how San Francisco's French restaurants inspired a member of the Bohemian Club to write a parody of "La Marseillaise," the French national anthem, using some of their names: "Marchand's! Marchand's! The Maison Riche, The Poodle Dog, The Pup!!" (Author's collection.)

HIPPOLITE D'AUDIFFRED. Born in France in 1830, Audiffred set sail for Mexico at the age of 20 to make his fortune. He headed for San Francisco in the 1860s, producing charcoal on the Mission Street Wharf to supply Chinatown's population. By 1889, Audiffred erected his own building on the waterfront, designed with Mansard architecture to remind him of his native France. (Author's collection.)

THE BULKHEAD. In 1906, the Audiffred building housed a seamen's saloon called the Bulkhead. As soldiers and firemen approached the building to blow it up and stop the spread of flames, the Bulkhead's quick-thinking saloon keeper made a bargain: for two quarts of whiskey per firefighter and a firehouse cart full of wine, the building would be spared. Only one other building on the waterfront block remained standing. (San Francisco Public Library.)

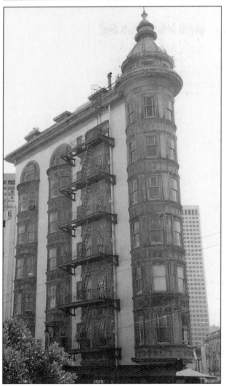

THE FRENCH RESTAURANTS SCANDAL. The 1906 disaster interrupted an investigation of "Boss" Abraham Ruef (seated left), the son of an Alsatian native who owned a dry goods store on Market Street. A key political figure in the corruption-plagued city government of the "Gay Nineties," this Berkeley Law School graduate was involved in many corrupt schemes, including levying "fees" for the renewal of liquor licenses for French restaurants, whose private dining suites could not survive without wine and champagne. (California State Library.)

THE SENTINEL BUILDING. This "flatiron" building, completed at great expense in 1907 only a few blocks from the old city hall, was designed to house Ruef's posh offices. Convicted of graft, Boss Ruef spent four and a half years in San Quentin prison before he could at last established his headquarters there. Movie director Francis Ford Coppola moved into the same suite decades later. (Author's collection.)

THE FRENCH-AMERICAN BANK. In February 1860, the French created the Société Française d'Epargnes et de Prévoyance Mutuelle, directed by Gustave Touchard for decades. Its offices were originally on Commercial Street and later on Bush Street near Kearny Street. In the 1870s, it was reorganized in the wake of fraudulent activities by then-director Gustave Mahé, who committed suicide, and in 1917 it became a new bank, the French-American Bank, with offices at 108–110 Sutter Street. Many other French businesses and institutions were housed in this building, including the French consulate, the Alliance Française, Ligue Nationale Française, the French library, French Mutual Benevolent Society, French-American Investment Company, insurers J. A. Bergerot and Pierre Lapachet, attorneys P. A. Bergerot, B. Lapachet, and S. J. Brun, architects Albert L. Lapachet and A. F. and C. M. Rousseau, and French tailor M. Léger. When it became a Bank of America in 1927, the French-American Bank had deposits of more than $20 million. (Author's collection.)

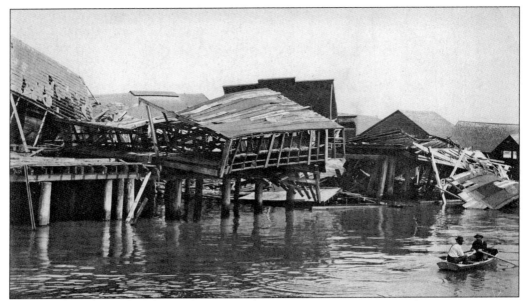

BUTCHERTOWN'S FRENCH COMMUNITY. The Butcher Reservation, created in San Francisco's Bayview area around the 1870s, was hard hit in 1906. The slaughtering shacks built over water collapsed. Promptly rebuilt, Butchertown boomed during World War I, developing into a unique community of 3,500 people from dozens of different nationalities. Censuses show French nationals were the most numerous with over 500 in the 1920s, ahead of Italians, Maltese, Germans, and Irish Americans. (San Francisco Public Library.)

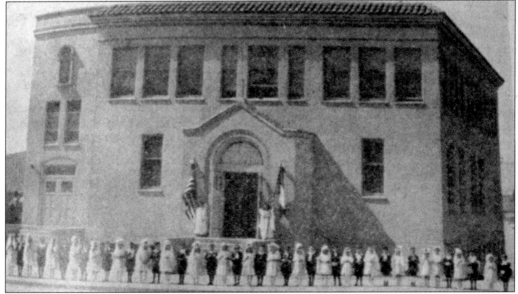

ST. JEANNE D'ARC CHURCH AND SCHOOL. The original St. Joan of Arc Chapel, built in 1910 on La Salle Avenue, soon proved too small for this booming French community. By 1922, it was replaced with a new building at Quesada Avenue and Lane Street, and included a chapel, five classrooms, and living quarters for the staff. Classes were primarily taught in English with students of all nationalities in attendance. (Author's collection.)

FRENCH BUTCHERS. Third-generation Béarnais Henri Bordenave grew up in Butchertown, "between the Bridge and Candlestick Park, Third Street and the Bay," as he recalled. At their home, his mother force-fed six geese a year, making foie-gras, duck confit, as well as blood sausage, pâté, and saucisson that filled their basement. His great-grandfather, born in Lurbes, was one of the earliest French butchers of Le South, as they called their community. (Author's collection.)

FORTY-NINER JULES AURADOU. After five years of gold digging, Jules Auradou Sr. returned to France. His son Jules Jr. stayed in the mines four more years before returning to San Francisco, marrying a French woman, and starting a meatpacking company. In 1870, he sold his business and purchased a ranch in Sonoma County, which is still owned by his descendent today. (Bill Auradou and Nancy Newkom.)

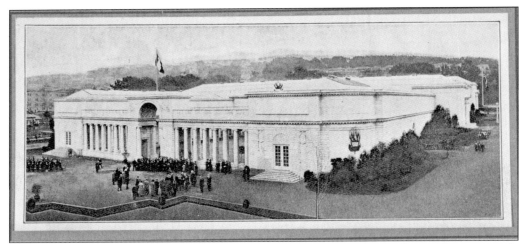

THE FRENCH PAVILION. The Palace of the Legion of Honor was designed in 1782 as a princely Parisian residence known as Hôtel de Salm. A the beginning of the 19th century that palatial building became headquarters for the Légion d'Honneur, the order created by Napoléon Bonaparte in 1802 to reward outstanding civic and military achievement. The French government used the architecture of the palace for its French art pavilion at the marina for the 1915 Panama Pacific International Exposition. (Author's collection.)

FRENCH CALIFORNIANS AT THE PPIE. Many French Californians participated in the long and complex organization of the PPIE, including architect Albert Pissis as a planner and Jules E. Pagès as a member of the international jury that awarded medals. French Californian Maurice Del Mué received a silver medal for painting in oil. (Reproduction gift of Mireille Piazzoni.)

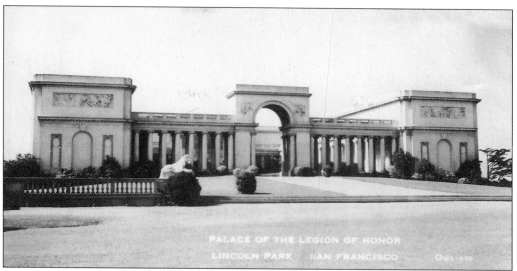

PALACE OF THE LEGION OF HONOR. Born in San Francisco to Danish parents of noble French origin, Alma Emma Charlotte Corday le Normand de Bretteville married sugar tycoon Adolph D. Spreckels. In 1924, she was able to bring the French culture she loved to San Francisco with a grand museum built at Land's End in Lincoln Park that cost her and her wealthy husband $1 million. Ground-breaking ceremonies were delayed by World War I, but on November 11, 1924, four months after Adoph Spreckels' death, the lavish museum was accepted on behalf of the city by Mayor James Rolph and formally dedicated to the memory of the 3,600 Californian men who died fighting in France. Rodin's *The Shades* statue was erected to the memory of the beloved Raphael Weill and now stands inside the palace. (Both, Author's collection.)

ECOLE NOTRE DAME DES VICTOIRES. The Fathers of Notre Dame des Victoires, who had purchased several empty lots on Pine Street behind the church, dreamed of creating a French school to bring their parishioners back together. Fathers Henri Gérard and Louis Le Bihan realized this dream: Notre Dame des Victoires School was built in 1907 on the foundation of an earlier building that had been dynamited to contain the 1906 fires east of Dolores Street. The old Mansard structure, main steps, and iron gates are from the original building and remain unique elements in one of San Francisco's most historic areas. It opened in January 1924 with 14 students. By the time Archbishop Edward Hanna blessed the building in November, there were 150 students attending. (Above, Fr. E. Siffert; below, San Francisco Public Library.)

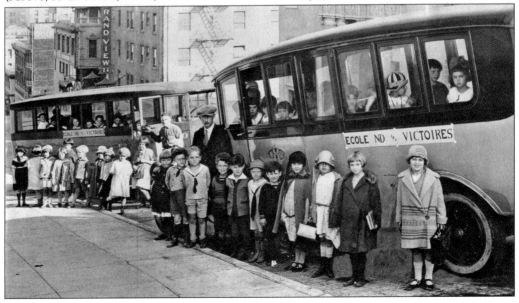

L'ECHO DE L'OUEST. Hatter and journalist Léon L. Rey was born in Nimes in 1854 and moved to San Francisco in 1885. There he opened his own hatter's shop using local jackrabbit fur for his top hats. He founded L'Echo de l'Ouest in 1909 as part of his efforts to help laundry workers obtain better work condition. (Author's collection.)

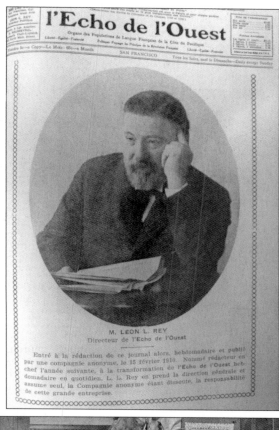

LE FRANCO-CALIFORNIEN. While L. L. Rey wrote for the workingman, Augustin Lusinchi was said to belong to the aristocracy of the French colony. He is at work here at the editing office of *Le Franco-Californien* newspaper in the 1930s. (Fr. E. Siffert.)

LA GAITE FRANCAISE. André Ferrier was a native of Caen in Normandy who, following his family's desires, studied at the University of Paris and at the Ecole de Pharmacie, all the while playing at Théâtre Sarah-Bernhardt, Porte St. Martin, L'Ambigu, and l'Odéon. Ferrier traveled the world and married a talented singer from Nancy, France, before settling in San Francisco. On August 14, 1912, Ferrier founded a popular French theater in the couple's home at Washington near Hyde Streets. The theater continued for 25 years and was advertised as "175 very comfortable seats, amusing and artistic play, careful interpretation, artistic scenery, elegant staging, great lighting and unusual effects, friendly reception." Lucien Labaudt, shown on the right with André Ferrier, created decors and costumes for the shows, as did French California artist Siméon Pelenc. (Both, author's collection.)

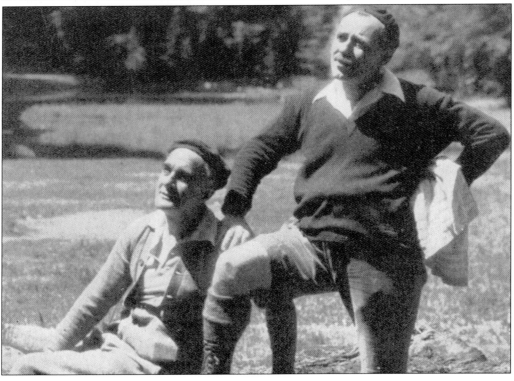

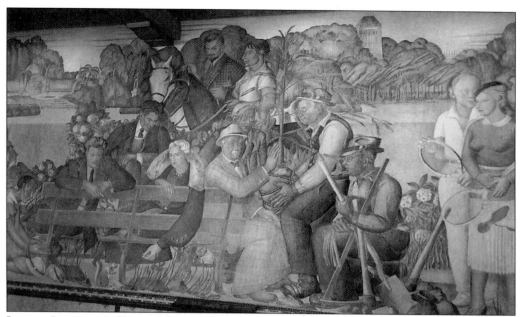

LUCIEN LABAUDT'S GREAT MURALS. Born in Paris on May 14, 1880, to a French banker and his artistic wife, Lucien Labaudt traveled to New York at age 24 to draw costume plates for fashion magazines. In 1909, he was commissioned as the designer for San Francisco's City of Paris store and soon made San Francisco his permanent home. He taught costume design at the California School of Fine Arts. In 1930, he founded and directed his own California School of Design. His 1934 Coit Tower stairwell fresco *Powell Street* is perhaps his best-known work. His *Beach Chalet* frescos show scenes of his friends and family at rest and play, a pendent to his other murals of Californians at work. Labaudt lost his life in 1843 in a plane crash above Burma as he traveled on an assignment for *Life Magazine*. (Author's collection.)

The Beach Chalet, Golden Gate Park, San Francisco, California. 88.

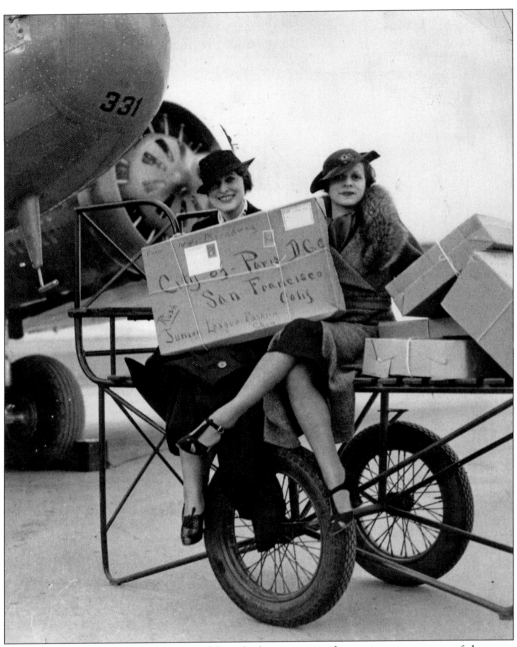

SAN FRANCISCO'S FRENCH IMAGE. Although there seems to be no apparent traces of the once formidable French community beyond its great historic legacy, San Francisco's French image survived with great names like Herb Caen and Pierre Salinger, businesses like Boudin and Peninou, and Guittard Chocolates, which remains the oldest family-owned business in California. Moulin Studio is now in its third generation. The great composer Darius Milhaud who emigrated to San Francisco in 1940 taught at Mills College, while his wife, Madeleine, taught in the drama department. By the end of the 1950s, her troop played at the Florence Gould Theater at the Palace of the Legion of Honor. (Phil Stroupe.)

Five

SAN FRANCISCO'S FRENCH COMMUNITY

The great French immigration to California dried up around the time of World War II. By then, the French language was generally no longer used in the meetings of San Francisco's many French associations. French laundries survived another decade, then faded when competition with American companies and home washing machines made them obsolete, except for a few that specialized in fine wash.

In the 1950s and 1960s, a cluster of Basque and southern French eateries and boarding houses, like the Basque Hôtel, Hôtel des Alpes, Hôtel de France, Obrero Hôtel, and Hôtel Pyrénées, sprang up on Broadway Street, as did Le Montmartre, a French club owned by Françoise Allemand. The club became a general rendez-vous for San Francisco's French and Francophile residents. A revival of French cuisine also brought exquisite new restaurants to town, as well as great French bakers and the beloved Marcel and Henri charcuterie.

Yet the city's formerly-formidable French presence continued to erode, and its landmarks slowly disappeared: the City of Paris closed its doors in 1974, two years after Paul Verdier's death. The San Francisco Landmark Advisory Board refused to give the building historic monument status and only the rotunda could be saved, now inside a Neiman Marcus store. The White House and Roos-Atkins followed suit, and in 1989, the French Hospital was sold to Kaiser Permanente.

Many institutions and associations did survive. San Francisco's French community today includes, besides its consulate, three French schools, the historic Notre Dame des Victoires , the Alliance Française, and the French American Chamber of Commerce, as well as a multitude of French associations that help their members maintain ties among themselves and with their native country, while providing continuity from one generation to the next.

There may be as many as 60,000 French natives in San Francisco and the Bay Area, including a recent infusion of fresh blood from the influx of the "Second French Gold Rush," businesses and experts from France settling in the Silicon Valley. Without a doubt, there remains "a special connection—both legacy and ongoing love affair—between the French and the City by the Bay," according to journalist Jacqueline Swartz.

STATE GUARD. French-born Paul Verdier, who had served as an infantry captain in World War I, took time from managing the City of Paris store during World War II to patrol San Francisco's Bay Bridge on horseback from midnight to noon as part of his duties as a Mounted California State Guard. (Author's collection.)

FRENCH RESISTANCE DAY. To remember the many young men who served in France during World War II, like Eugène Mertz who worked as translator under Pershing, there were many war efforts organized San Francisco's French colony as well as patriotic celebrations like this June 1944 ceremony, which honored French resistant fighters at the Palace of the Legion of Honor. (San Francisco Public Library.)

FRANCE'S MERCI TRAIN. In 1947, radio commentator Drew Pearson launched what became a nationwide effort to send food to Europe. Local drives were organized, and trains originating from several points in the country converged to form the "American Friendship Train": 700 boxcar-loads of food, fuel, and clothing. A total of $40 million in relief supplies were shipped to Le Havre, France, in 1948 and distributed directly throughout the country, especially to children and older adults. The suggestion to reciprocate came from a French railroad worker and war veteran named André Picard. An estimated six million French citizens contributed works of art, food, wine, needlework, local specialties, furniture, and homemade toys. By the end of 1948, forty-nine boxcars filled with gifts had been collected throughout France and shipped to the United States aboard the merchant ship *Magellan*, arriving in New York Harbor in early February 1949. Each state received one boxcar containing between 500 and 600 gifts, and one was shared by the District of Columbia and the territory of Hawaii. (San Francisco Public Library.)

THREE GENERATIONS OF MOULIN. Gabriel Moulin was born in 1872 in San Jose, of French and German lineage (his great grandfather emigrated from Paris around 1860) and in 1884 moved to San Francisco with his family. Gabriel apprenticed with Isaiah West Tabor, the city's leading photographer, capturing images of the Midwinter Fair of 1894, the Bohemian Club encampment along the Russian River, and the redwoods along the coastline. Later he branched out with other business partners, photographing the 1906 earthquake devastation, the 1915 Panama Pacific International Exposition, and many more as the owner of Moulin Studios, which today holds more than 100,000 images of Bay Area history from the 1880s to modern times. His sons Irving and Raymond and grandson Tom have all contributed to the collection with their own photographic works. This composite image shows, from left to right around Gabriel's portrait, Raymond, Irving, and Thomas Moulin. (©Moulin Studios.)

MOULIN ARTISTRY. This image of the Golden Gate, with stark silhouettes of pelicans in the foreground, is an example of the artistic photography of Thomas Moulin. Tom continues the family's photographic work into today's era, working in traditional film and digital media for various topics and a large clientele. (©Moulin Studios.)

The French in California

ONE HUNDRED YEARS OF ACHIEVEMENT

HENRI L. BONNET

French Ambassador to the United States, who is now in San Francisco for the centennial celebration

SAN FRANCISCO CHRONICLE

THURSDAY, NOVEMBER 16, 1950

FRENCH PIONEER CENTENNIAL DAYS. The brainchild of Dr. Raoul Blanquié and Prof. Gilbert Chinard, both historians of California's French heritage, this large-scale 1950 French centennial celebration in San Francisco coincided with California's own centennial. Mayor E. Robinson called November 11–30, 1950, "French Pioneer Centennial Days." French Californians were treated to a play by André Ferrier, a performance by Les Petits Chanteurs de la Croix de Bois, the dedication of a plaque to François Pioche, an exhibit of French art and mementos, a centennial banquet, and a grand Mass at Notre Dame des Victoires . Journalist Jehanne Biétry-Salinger, mother of Pierre Salinger, traveled the state to gather material for the exhibition and for a companion book, *Notre Centenaire*, filled with information on California's pioneers. (Both, author's collection.)

Paris Comes to San Francisco. A colorful reproduction of the Eiffel Tower wrapped around Union Square's Dewey column was the focus of this weeklong Festival of France organized by the French community in 1967. It towered over the Café de France, an outdoor café set up in Maiden Lane, which was filled with booths offering French products from freshly cooked crèpes, to perfume and fashion items. For a week, American and French stores around Union Square also dedicated windows and special sales to their "made in France" items. Mayor Jean Auburtin of Paris was on hand for the occasion. (Associated Press.)

A Renewal of French Cuisine. A score of great new French-owned restaurants appeared in San Francisco from 1950 to 1970, among them Le Normandy, le Trianon, la Bourgogne, l'Etoile, Chez Michel, Le Tricolore, Le Cyrano, and La Fleur de France, with great young chefs from France. Fleur de Lys alone survived and now thrives with a dynamic partnership between Maurice Rouas and world-renowned chef Hubert Keller. (Pierre Mattot.)

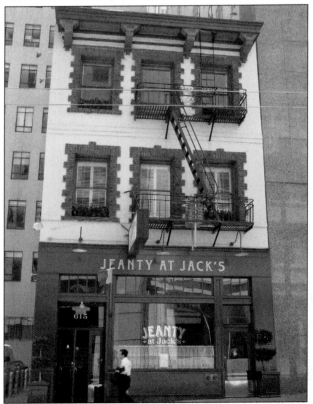

San Francisco' Oldest French Restaurant. Jeanty at Jack's in the heart of old San Francisco is now the city's oldest French restaurant. Chef Philippe Jeanty has recreated the feeling of an old Parisian neighborhood brasserie with red-colored wood paneling, lace curtains, and brass lighting. (Pierre Mattot.)

THE SAILING SHIP. Built in 1862 near Bordeaux, this yacht was used by Prince Albert to collect marine specimens for his Oceanographic Museum in Monaco. Chartered by Jules Verne while writing *20,000 Leagues Under the Sea*, it was motorized in 1908 for transporting cognac, became an Allied World War I espionage vessel, was a rumrunner during Prohibition, and then was acquired by a wealthy Argentinean for celebrity parties. Beginning in 1930, the ship was featured in more than 70 major films, including *Moby Dick*, *Mutiny of the Bounty*, *Treasure Island*, *Shipwrecked*, *Captain Kidd*, *The Buccaneer*, and *Captain Blood*. Dolph Rempp brought it to San Francisco in 1973. Land-bound at Pier 42, it became the beloved Sailing Ship restaurant. By 2002, the city's redevelopment agency, overruling all petitions, had the grand old ship "chewed down to a stub." (Both, Author's collection.)

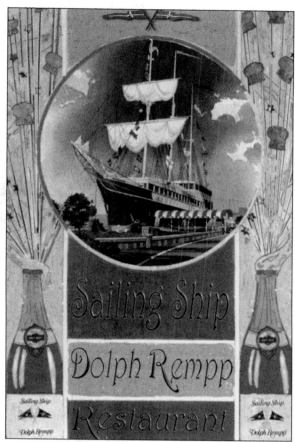

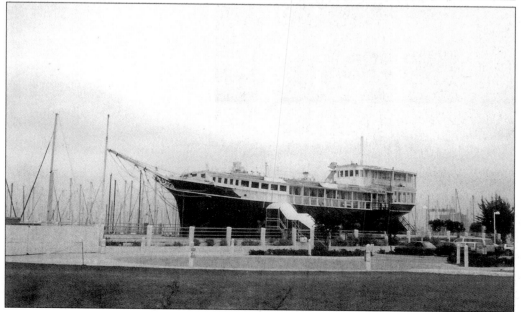

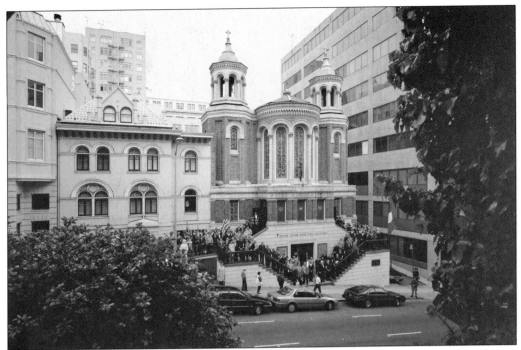

HISTORIC LANDMARK. Eglise Notre Dame des Victoires was declared a historical landmark in 1984. On the occasion of the church's 2006 sesquicentennial celebrations, Fr. Etienne Siffert, who was appointed to the church in 1975, wrote an illustrated booklet of the church's history. Notre-Dame remains a hub for special French occasions in San Francisco, like this March 1993 ceremony welcoming the officers and sailors of the French training ship *Jeanne-d'Arc.* (Robert E. David.)

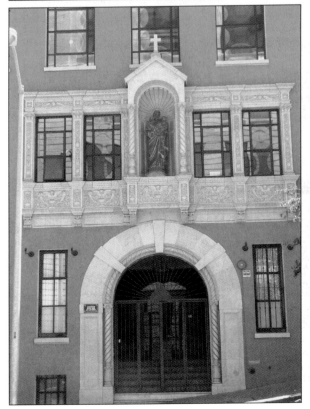

NOTRE DAME DES VICTOIRES SCHOOL. The school opened in 1924 in order to serve the area's growing French community. Today it maintains its long-standing tradition of educating children in the French language and culture. The Marist Fathers and the Sisters of St. Joseph of Orange, who were instrumental in the establishment of the school, continue to be involved in its running and direction. (Pierre Mattot.)

THE FRENCH-AMERICAN INTERNATIONAL SCHOOL. Richard Ham, Germaine Thompson, Michel Weill, and Claude Reboul were among the cofounders of the French-American International School (FAIS), designed in 1962 as an alternative independent school originally modeled on the best French Lycées in London, Paris, and Geneva. FAIS's current campus at the heart of San Francisco's Cultural Center was inaugurated by Mayor Willie Brown. Mayor Gavin Newson is an alumnus. FAIS appears in Armistead Maupin's *Tales of the City*. (FAIS.)

LYCEE FRANCAIS LA PEROUSE. Among the Lycée's founders in 1967 were Claude Reboul, Yvon d'Argencé, and Henri Monjauze. Parents and teachers wished to provide a total, immersive French education program adhering to the curriculum of France's national education system. This new building was inaugurated in 1997 with Nancy Pelosi, French senator Jacques Habert, and Lapérouse's descendent Madame Yves Pestel present. (Pierre Mattot.)

FRANCE-AMÉRIQUE. In existence since 1943, the bimonthly newspaper *France-Amérique* was relaunched in April 2007 after a major revamp, merging with the *Journal Français*, the leading monthly French-language newspaper published in America since 1978. It is the largest French-language publication in the United States with a 20,000 print circulation and 60,000 readers. In 2000, *France-Amérique* celebrated the sesquicentennial of the Gold Rush with two special issues on California's French pioneers. (Author's collection.)

ALLIANCE FRANCAISE. Founded in 1889 by French teacher Xavier Mefret, the Alliance Française started to provide French classes to San Francisco schools around 1895, thanks to writer Daniel Lévy. In 1997, it moved from Mason Street to a new building at 1345 Bush Street purchased by Ligue Henri IV under the initiative of the Alliance's president, Edouard Serres. Today it is a thriving language school and cultural center. (Pierre Mattot.)

FRENCH ASSOCIATIONS. The strength of the French presence in San Francisco shows clearly in the number of clubs and associations that are in existence today. (Above, Pierre Mattot; right, French consulate.)

- CHAMBRE DE COMMERCE FRANCO-AMERICAINE
- COMITE OFFICIEL DE LA COMMUNAUTE FRANCAISE DE SAN FRANCISCO ET DE LA BAIE
- AMICALE DES ANCIENS MARINS DE CALIFORNIE
- ANCIENS COMBATTANTS D'AFRIQUE DU NORD
- ANCIENS H.E.C. DE L'OUEST DES ETATS-UNIS
- BASQUE CLUB OF CALIFORNIA Inc.
- LA BIBLIOTHÈQUE ORANGE
- SAN FRANCISCO BAY ACCUEIL
- D.B.F.
- LES CHASSEURS Inc.
- CONSEIL NATIONAL DES INGENIEURS ET SCIENTIFIQUES DE FRANCE
- LES FANEURS, Inc.
- FRENCH ATHLETIC CLUB
- L'ILE DE FRANCE
- LIGUE HENRI IV
- LA PARFAITE UNION
- SOCIÉTÉ D'ENTRAIDE
- SOCIÉTÉ " LA GAULOISE "
- UNION DES FRANÇAIS DE L'ÉTRANGER
- LES AMIS DE LA CULTURE FRANÇAISE
- ANCIENS COMBATTANTS FRANÇAIS ET SOLDATS DE FRANCE
- ASSOCIATION DEMOCRATIQUE DES FRANÇAIS A L'ETRANGER
- BASQUE CULTURAL CENTER
- CITROEN CAR CLUB, INC.
- LA BOULE JOYEUSE
- CONFRERIE DE LA CHAINE DES ROTISSEURS
- ÉGLISE NOTRE DAME DES VICTOIRES
- FRENCH HERITAGE ALLIANCE
- FRIENDS OF VIEILLES MAISONS FRANÇAISES, Inc.
- LES JARDINIERS FRANÇAIS
- LAFAYETTE - LANGEAC SOCIETY
- LOGE FRANCO - AMÉRICAINE
- SAN FRANCISCO BAY ACCUEIL
- SOCIÉTÉ FRANÇAISE DE BIENFAISANCE MUTUELLE
- SOCIÉTÉ DU SAINT SACREMENT

"La Marie, Le Café, L'Eglise." On morning of 1992, as Jean Gabriel, owner of the European Bookstore and Café de la Presse, walked out of his café and surveyed the corner of Bush and Grants Streets, it occurred to him that the French church, French consulate, Le Central and other cafés and restaurants with their constant parade of people resembled "a little French village." He incorporated the name "French Quarter," a gesture that revived more than an idea, but a reality, since the corner at Bush and Grant Streets was in gold rush time of the argonauts' temporary "French Camps." (Both, Jean and Sara Gabriel.)

CAFE
de la
PRESSE

FROM THE
4TH OF JULY
~ TO ~
BASTILLE DAY
2003

SPECIAL MENUS
CHEF DE CUISINE
PATRICK ALBERT

★ MUSIC ★

COSTUMES D'ÉPOQUE

SAN FRANCISCO

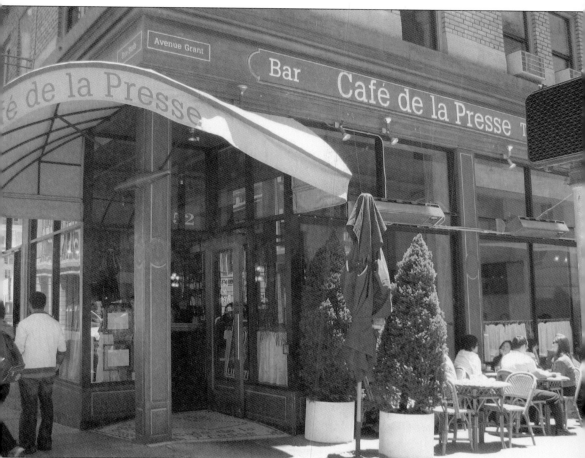

SAN FRANCISCO'S NEW FRENCH QUARTER. San Francisco again has its French Quarter, a historic enclave of restaurants, cafés, hotels, and institutions centered on Bush Street and in the adjacent alleys of Belden Place and Claude Lane near the gates of Chinatown. Landmarks in the French Quarter include the venerable Notre Dame des Victoires church, where Sunday Mass is celebrated in French, the offices of the French consulate, and several authentically Parisian bistros like Café de la Presse and Café Bastille. The Alliance Française is several blocks to the west. (Pierre Mattot.)

ACROSS AMERICA, PEOPLE ARE DISCOVERING SOMETHING WONDERFUL. THEIR HERITAGE.

Arcadia Publishing is the leading local history publisher in the United States. With more than 4,000 titles in print and hundreds of new titles released every year, Arcadia has extensive specialized experience chronicling the history of communities and celebrating America's hidden stories, bringing to life the people, places, and events from the past. To discover the history of other communities across the nation, please visit:

www.arcadiapublishing.com

Customized search tools allow you to find regional history books about the town where you grew up, the cities where your friends and family live, the town where your parents met, or even that retirement spot you've been dreaming about.